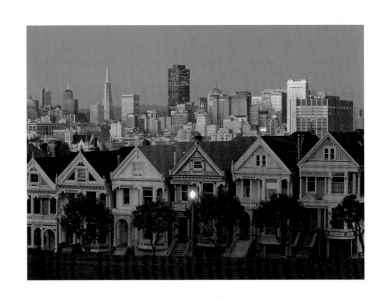

SAN FRANCISCO

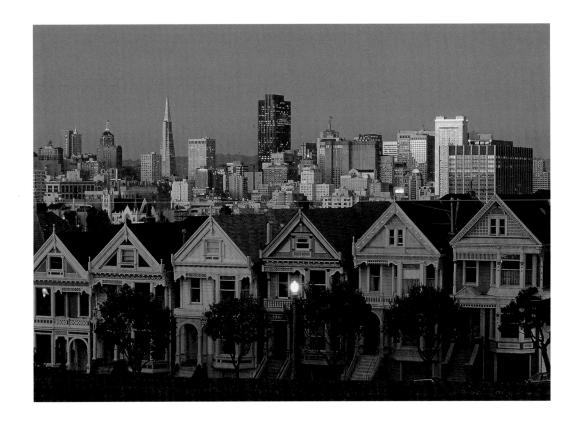

whitecap

The information in this book is true and complete to the best of our knowledge. All
recommendations are made without guarantee on the part of the author or Whitecap
Books Ltd. The author and publisher disclaim any liability in connection with the use
of this information. For additional information please contact Whitecap Books Ltd.,
351 Lynn Avenue, North Vancouver, British Columbia, Canada, V7J 2C4.

Text by Tanya Lloyd Kyi
Edited by Elaine Jones and Mark Macdonald
Photo editing by Tanya Lloyd Kyi
Proofread by Lisa Collins
Cover layout by Jacqui Thomas
Interior layout by Jane Lightle

Printed and bound in Canada

National Library of Canada Cataloguing in Publication Data

Kyi, Tanya Lloyd, 1973–
 San Francisco

 (America series)
 ISBN 1-55285-356-X
 ISBN 978-1-55285-356-6

 1. San Francisco (Calif)—Pictorial works. I. Title. II. Series:
Kyi, Tanya Lloyd, 1973– America series.
F869.S343K94 2002 979.4'61054'0222 C2002–910805–5

The publisher acknowledges the support of the Canada Council and the Cultural
Services Branch of the Government of British Columbia in making this publication
possible. We acknowledge the financial support of the Government of Canada through
the Book Publishing Industry Development Program for our publishing activities. We also
acknowledge the financial support of the province of British Columbia through the Book
Publishing Tax Credit.

For more information on the America Series and other Whitecap Books
titles, please visit our website at www.whitecap.ca.

The fog begins to lift at noon and a few patches of blue are showing over the water. The Financial District is abuzz with life, as people pour from office buildings toward the neighborhood eateries or the popular lunch spots of SoMa. Cable cars clang their way up nearby hills. The merchants of Chinatown are in the midst of the dim sum rush, seating new patrons even as the sated ones gather their belongings.

At Fisherman's Wharf, visitors embark on the day's activities. While some wander toward the fresh crab vendors and corner bakeries, others dine under the bright stripes of patio awnings. A crowd gathers to watch a street performer, painted silver and standing as still as a tin man until a coin is dropped into his hat and he creaks into robotic movement. Seagulls skirt the scene, swooping from above and plodding along like fellow pedestrians on the sidewalk. In the distance is a faint barking—the sound of sea lions lounging on the docks.

For the 776,000 people who live here and the millions more who visit each year, this collage of sights and sounds is what defines San Francisco. The metropolis along the shores of San Francisco Bay has more symbols than some small countries. There's the Golden Gate Bridge, Alcatraz Island, Ghirardelli Square, and the intersection of Haight and Ashbury—all immediately recognizable as San Francisco landmarks. In no other city does the vibrant life of the Haight and the Castro districts meld so easily with the mansions of Nob Hill and Pacific Heights. Nowhere else does the gold-seeking, sea-faring past spring to life so readily, on the streets below the office towers central to the high-tech industry.

From the steep and winding streets and decorative Victorian homes to the vineyards north of the city and beaches to the south, this book is an invitation to explore San Francisco's most famous sights. Separately, the images represent neighborhoods, parks, and attractions. Together, they capture both the city's relaxed atmosphere and its unmistakable energy.

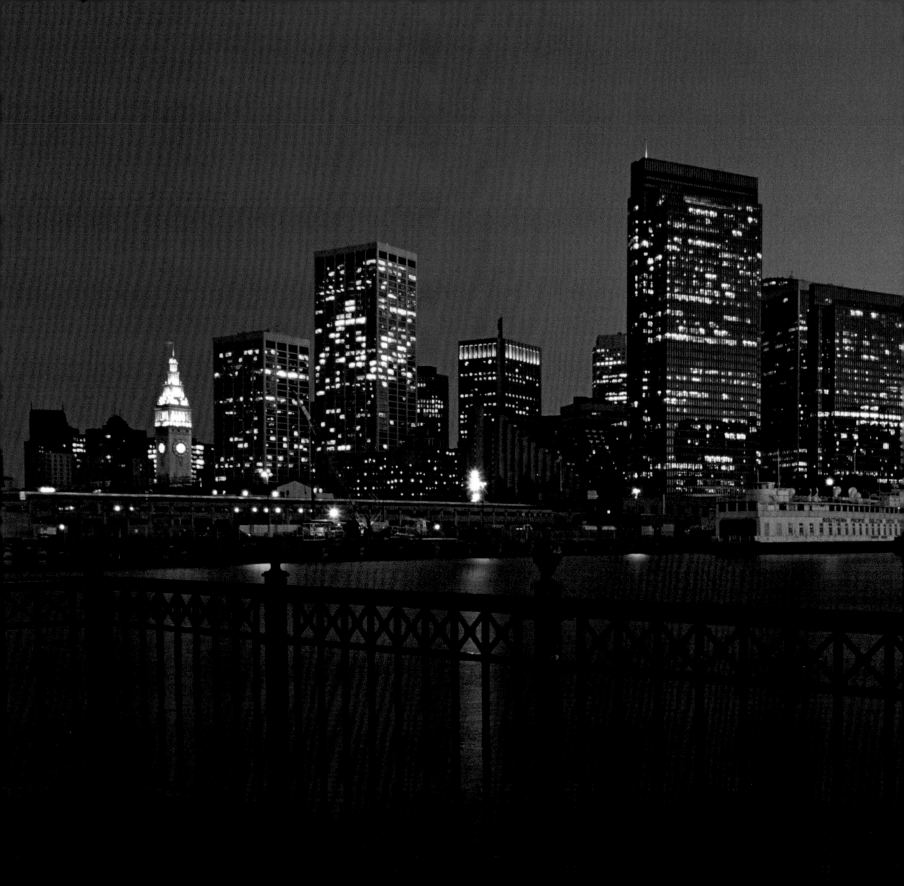

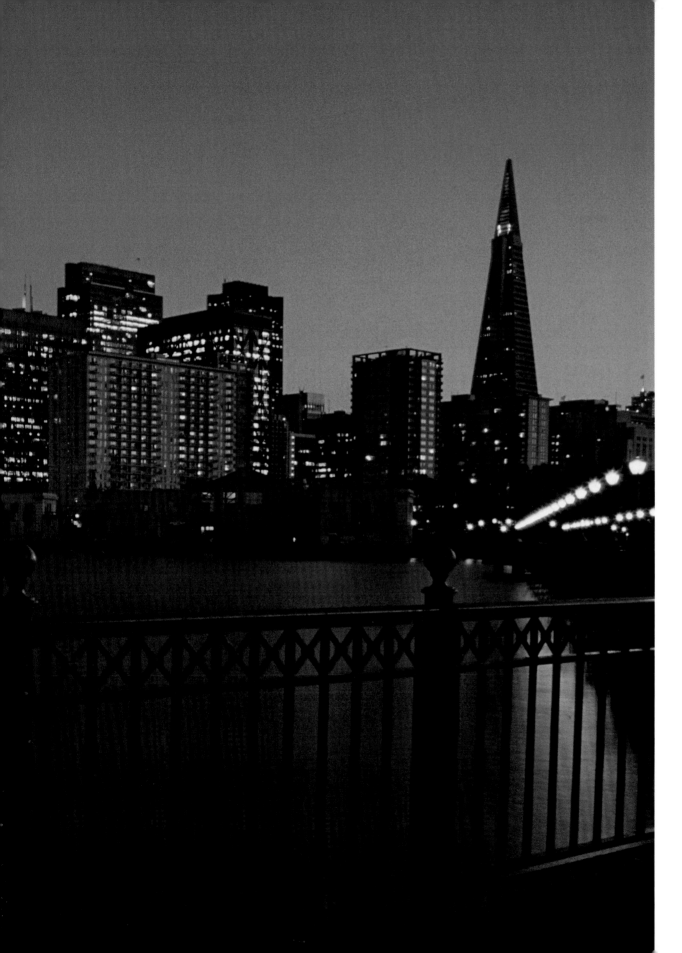

When Spanish
explorers sailed
into San Francisco
Bay in the mid–1500s,
they named the 450-
square-mile expanse
of water for St. Francis
of Assisi. The Spanish
fort and mission
established here in the
1700s adopted the
same name.

When the gold rush brought new prosperity to the city, the cows moved out of Cow Hollow and the city's elite moved in, building ornate Victorian homes. Today's entrepreneurs have transformed these heritage buildings into bed and breakfasts, retail stores, antique shops, cafés, and art galleries.

FACING PAGE—
In the late eighteenth century, while the young city was growing along the shore, the area that is now Union Street was lush pasture, fed by freshwater streams and bordered by a lagoon. Dairy farmers grazed their herds here, and the land became known as "Cow Hollow," a name still heard today.

9

Founded in 1935, the San Francisco Museum of Modern Art houses painting, sculpture, photography, architecture, design, and media arts from the last century. From the imagery of Ansel Adams to contemporary on-line creations, the museum both preserves pioneering works of American artistry and sparks new exploration.

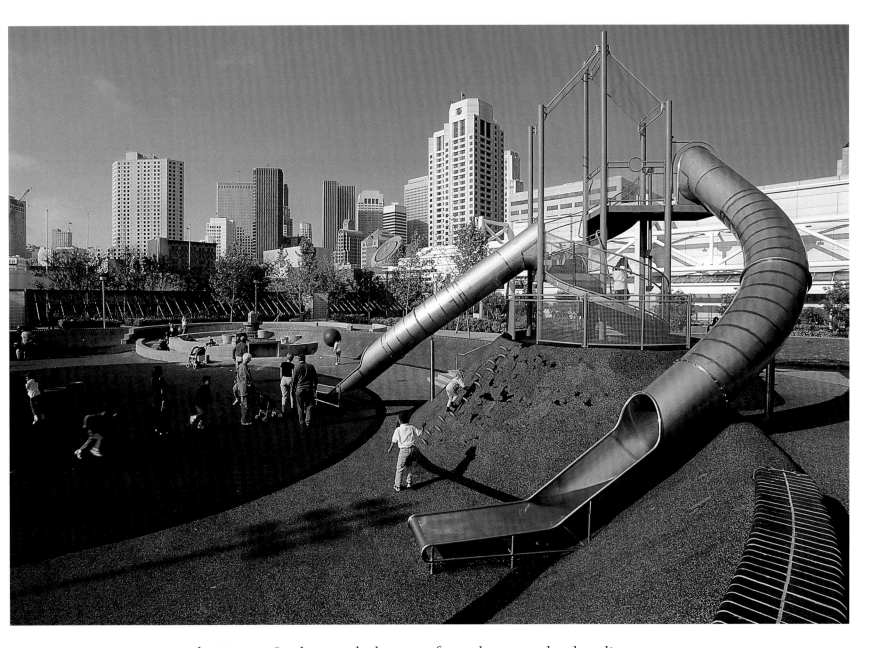

Yerba Buena Gardens includes a rooftop playground, a bowling center, a children's garden, and a skating rink, all atop the Moscone Center, San Francisco's primary convention venue. The complex is located in SoMa, the district south of Market Street known for its nightlife.

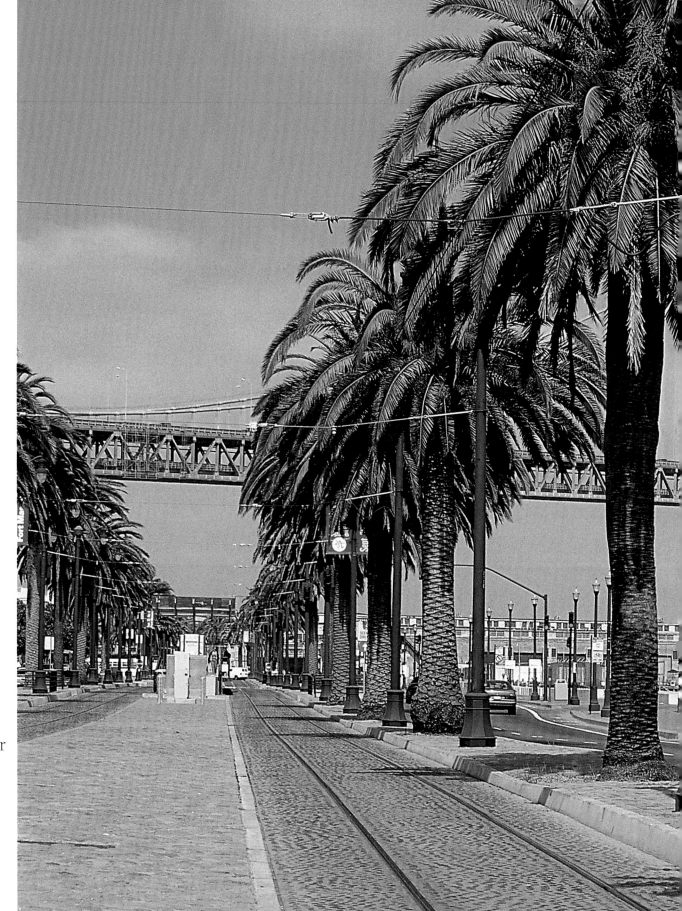

A sunny afternoon draws visitors to the South Beach area, just moments from downtown. Although the city is known for its cool, foggy climate, summer temperatures regularly reach 72 degrees, and September and October are even warmer.

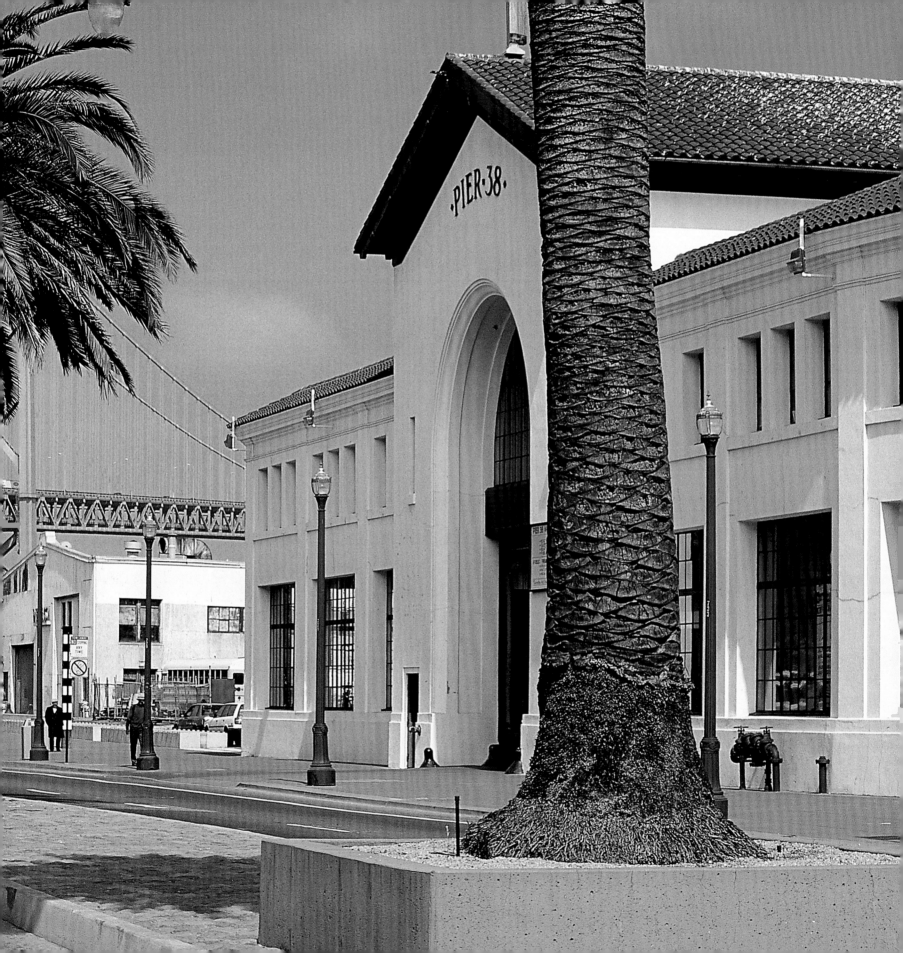

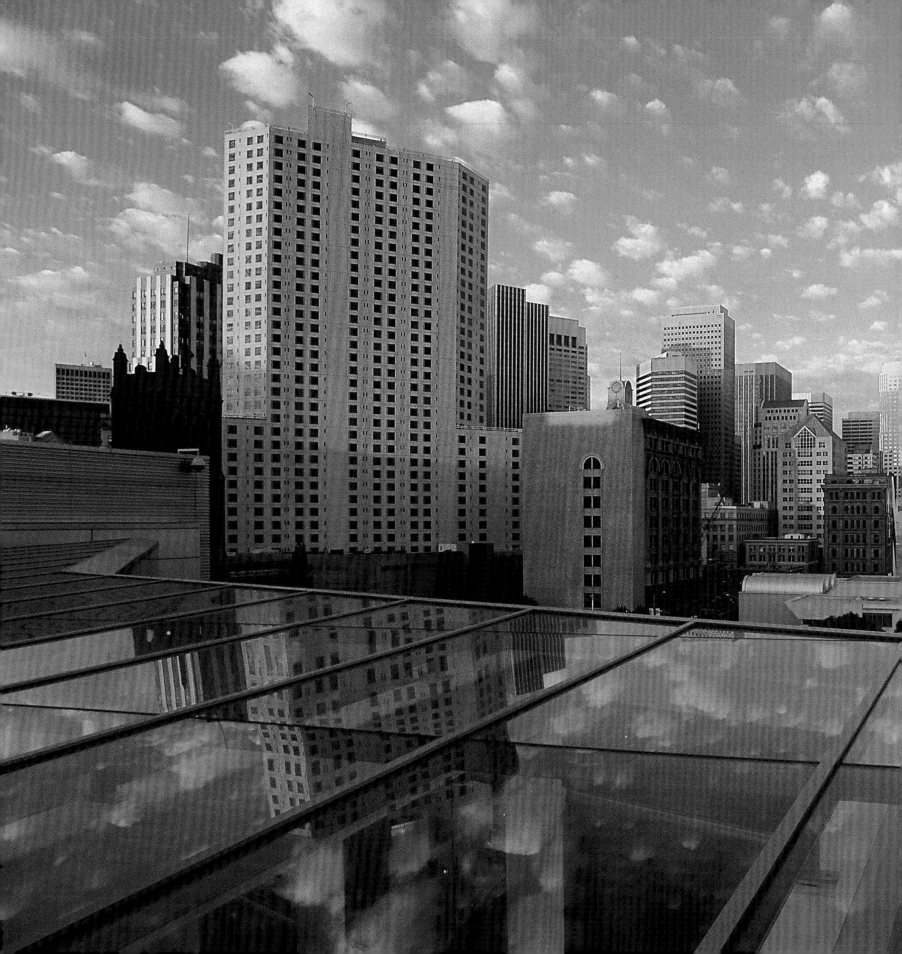

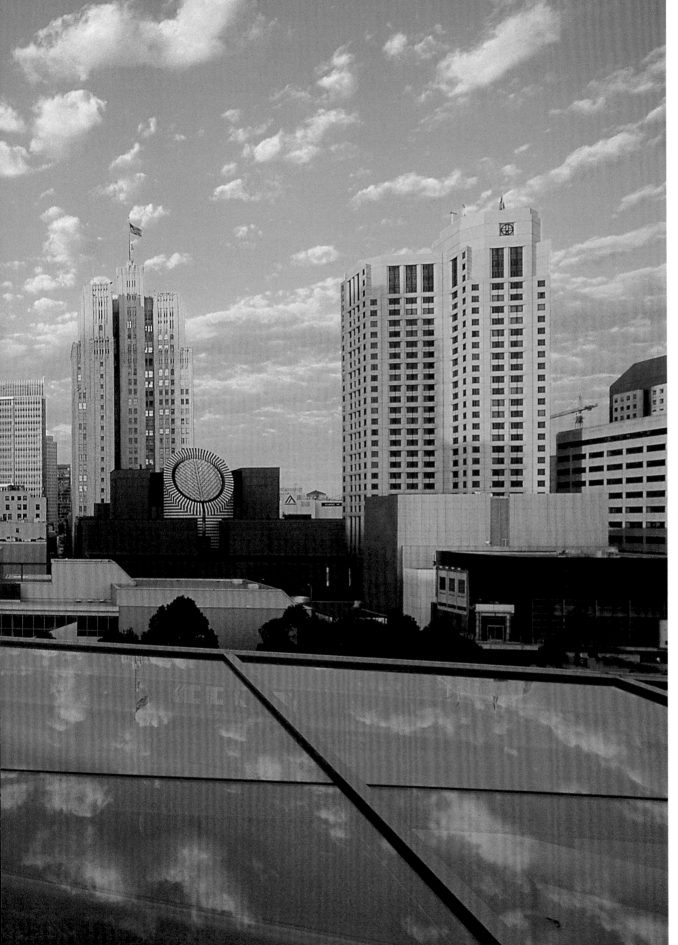

Through the devastating fire of 1906, the earthquake of 1989, and through the city's transformation into a modern commercial center, reminders of San Francisco's history have survived. The Gold Rush Trail leads visitors through the downtown skyscrapers to historic plazas, heritage buildings, monuments, and museums.

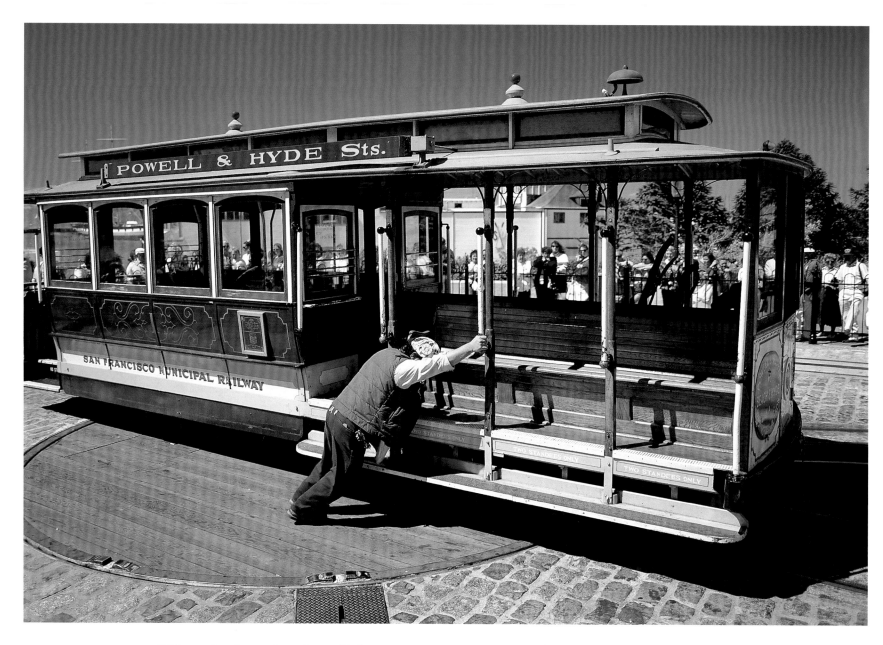

When Andrew Smith Hallidie saw a steep street send a horse-drawn carriage slipping toward disaster in the 1860s, he envisioned a new form of transportation for the city. Public cable car service began in 1873 and continues today.

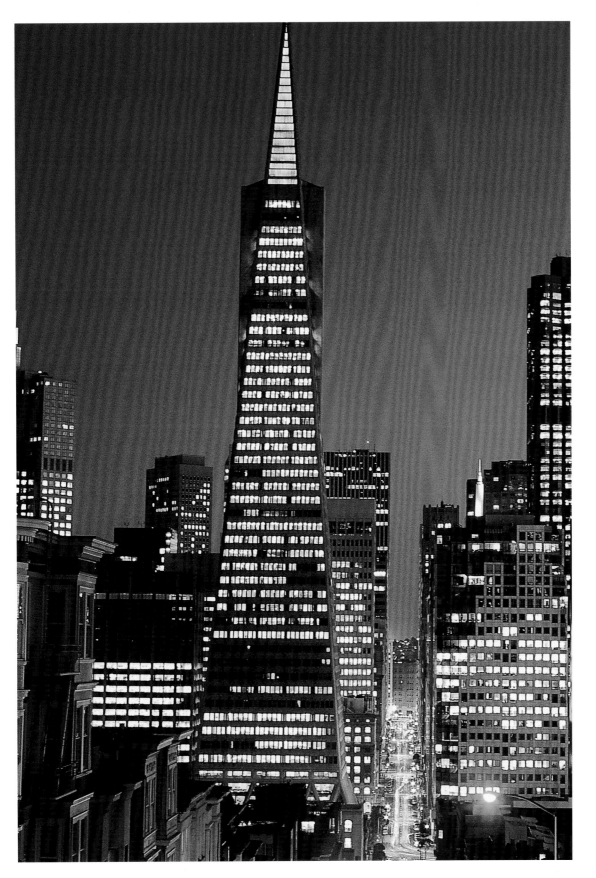

The 853-foot-tall Transamerica Pyramid is visible throughout the city. The building's design offers flexible floor plans to tenants—the highest floors are about 2,000 square feet, while the lower floors offer ten times that much space. The building's sloped walls also allow sunlight to reach the streets below.

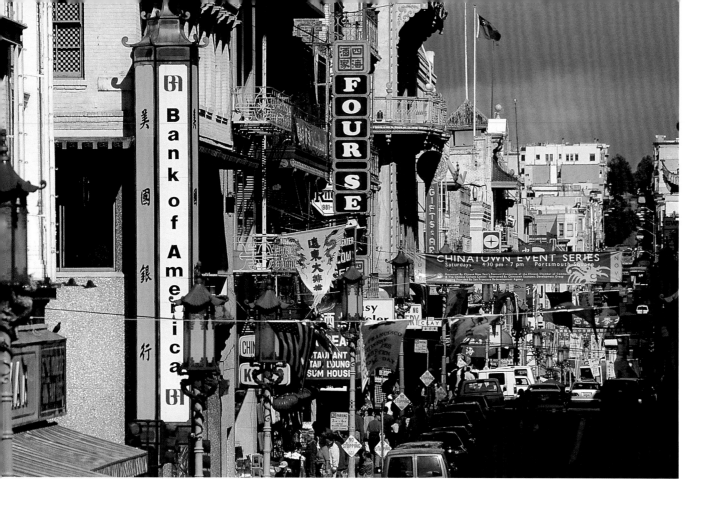

San Francisco's 24-block Chinatown is the largest in North America. Wandering the busy neighborhood, visitors can sample dim sum, shop for antiques or traditional medicines, watch fortune cookies being made, or explore Chinese-American history at one of several museums and cultural centers.

The California gold rush lured thousands of Chinese immigrants to San Francisco in the mid–1800s. Their hopes were short-lived—countless workers died building the transcontinental railway, while anti-Chinese laws and labor protests made life difficult. The Chinese Exclusion Act, which severely limited immigration, wasn't repealed until 1943.

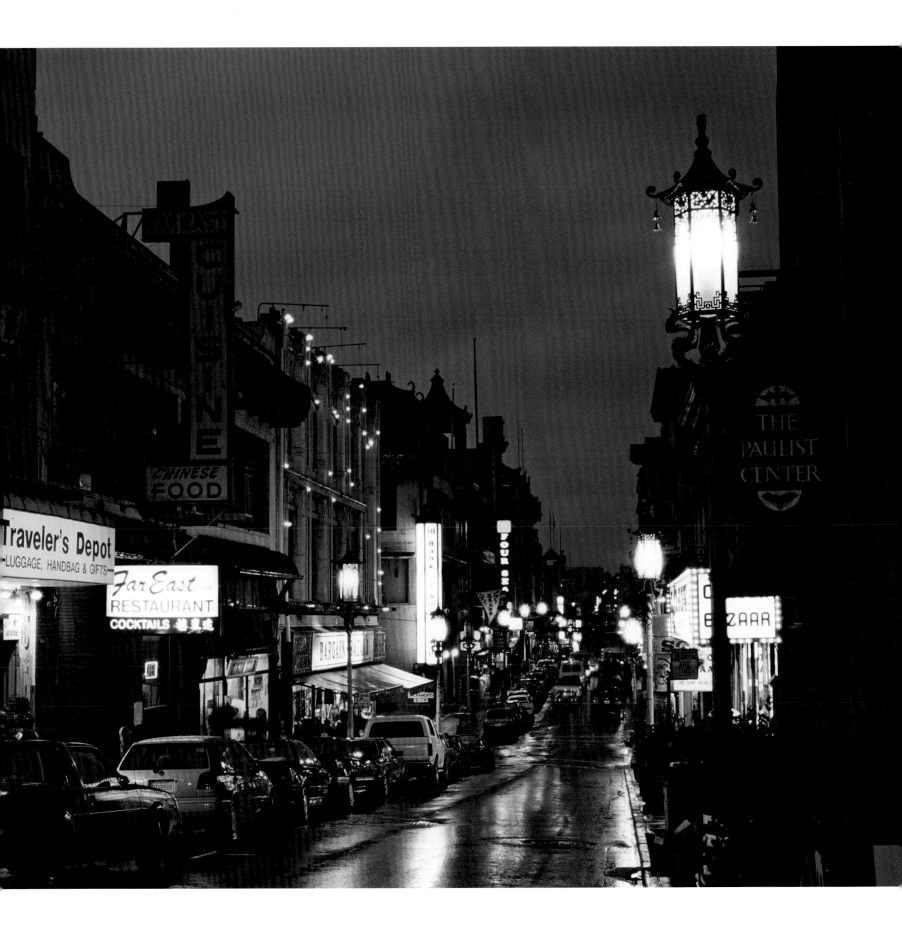

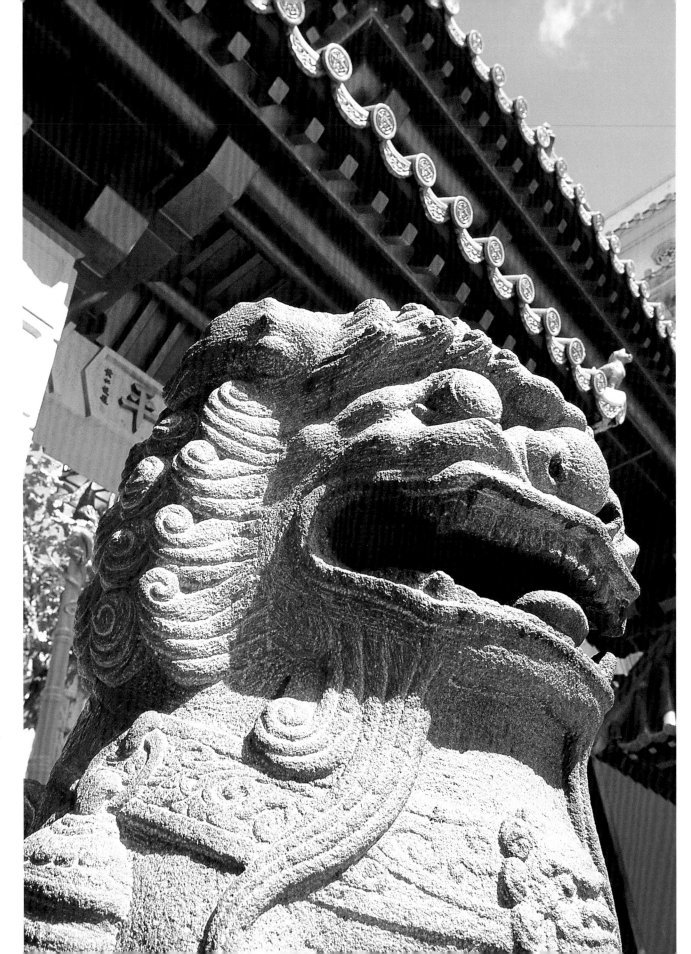

Stylized lions guard the ornate gate that marks the entrance to Chinatown. The words inscribed on the gate—"All under heaven is for the good of the people"—are attributed to Dr. Sun Yat-sen, a Chinese revolutionary who lived in San Francisco in 1910 and 1911.

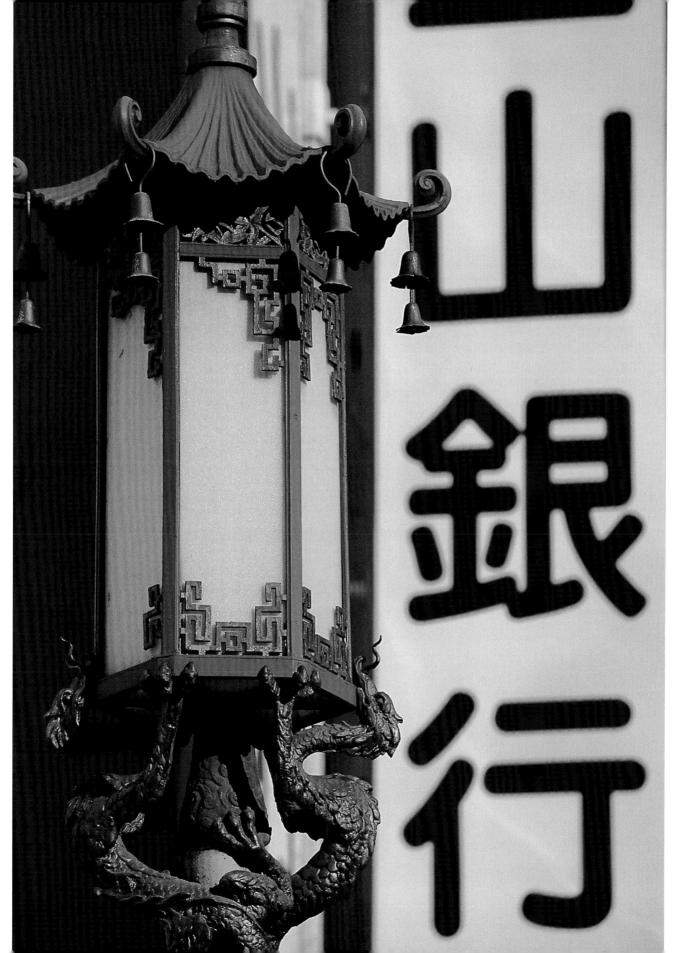

Grant Avenue's distinctive street lamps were created in the 1920s. As Chinatown slowly became a tourist destination, the Chinese Chamber of Commerce sought new ways to bring cultural and architectural interest to the neighborhood.

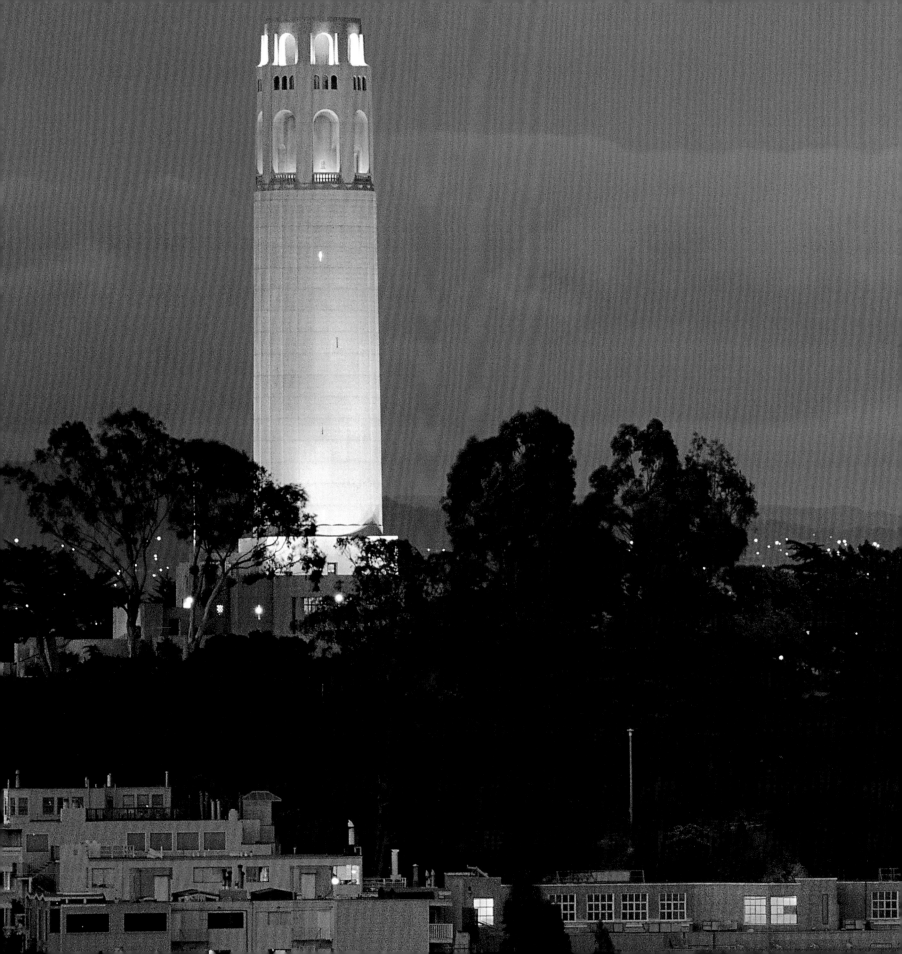

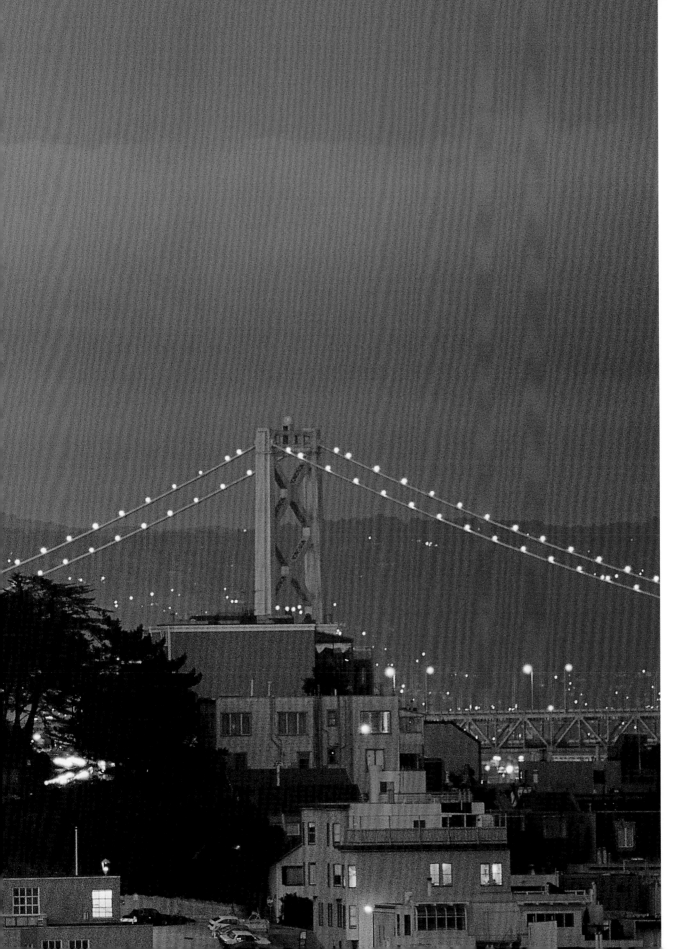

As a child, Lillie Hitchcock Coit was fascinated by firefighters, and turned up at so many city emergencies that the fire department made her an honorary member. She left the city a legacy upon her death, which was used to build Coit Tower, in honor of those who battled the blaze of 1906.

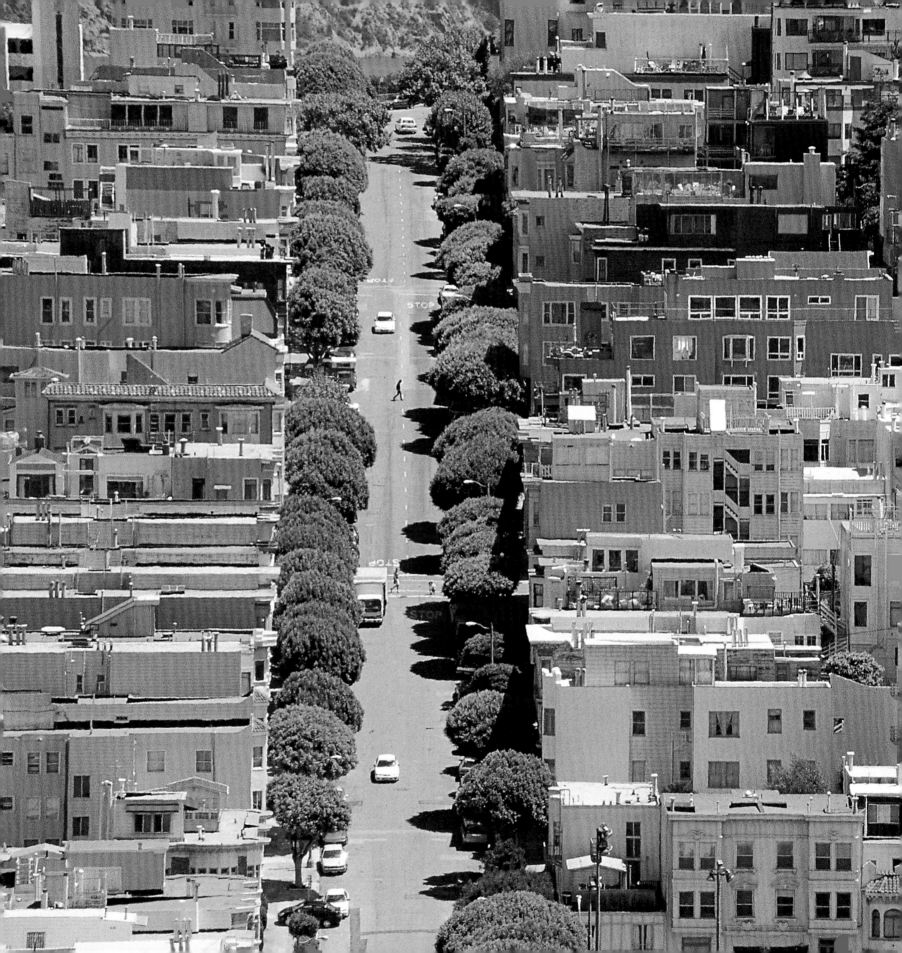

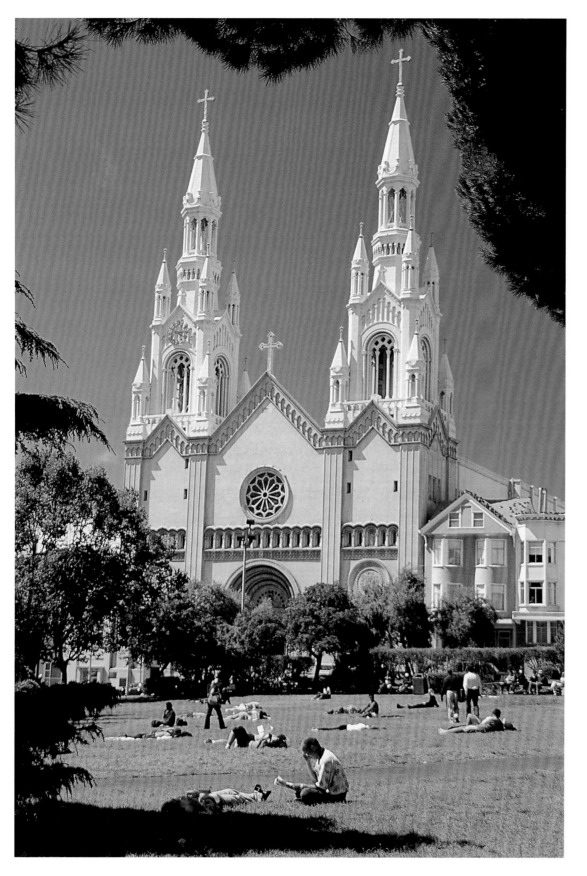

In the heart of North Beach, Saints Peter and Paul Church casts its shadow over Washington Square. This area was once home to the city's fishermen, and Saints Peter and Paul was often called the "fisherman's church." Today, the parish offers services in English, Italian, and Cantonese.

FACING PAGE—
For rich tiramisu, strong espresso, or thinly sliced prosciutto, San Francisco residents look to Little Italy and San Francisco's North Beach neighborhood. Bakeries, delicatessens, and restaurants beckon during the day, while strip clubs and upscale dance bars compete for the nightlife.

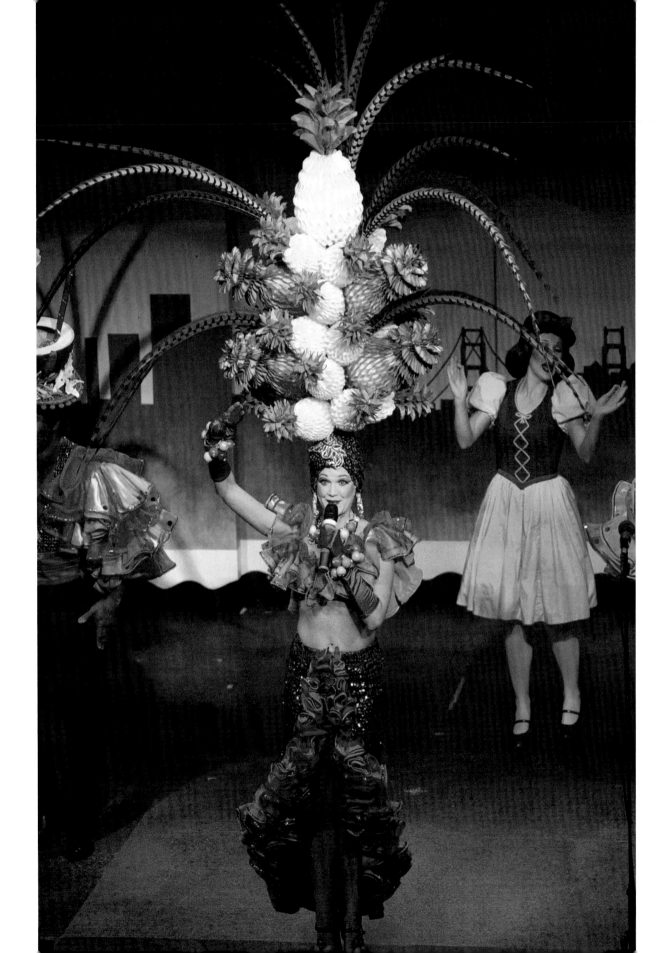

For more than 25 years, *Beach Blanket Babylon* has offered a unique combination of outrageous costumes and musical parody. Impersonations of pop culture icons, celebrities, and politicians have drawn sold-out crowds to more than 10,000 performances.

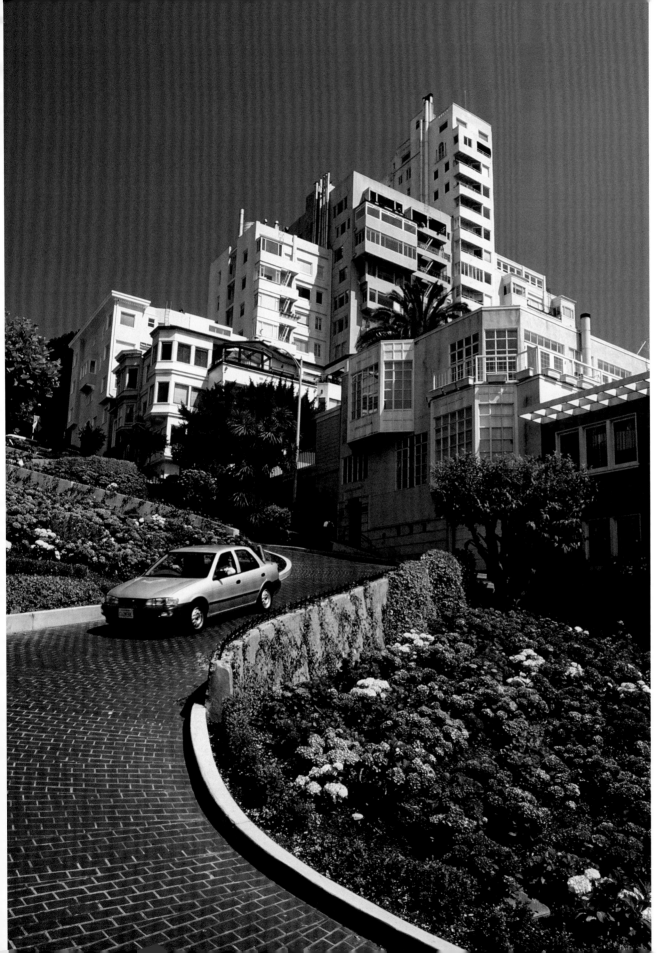

Billed as the crookedest street in the world, Lombard Street winds down one of two summits in San Francisco's Russian Hill neighborhood. Many visitors drive down the street's steep switchbacks, while others choose to walk the stairway alongside— one of 300 stairways throughout the hilly city.

27

Railway baron Collis P. Huntington was among the first of San Francisco's elite to build a stately home on Nob Hill. When fire destroyed the mansion, his widow, Arabella, donated the land to the city. The lush, manicured park now occupies some of San Francisco's most valuable property.

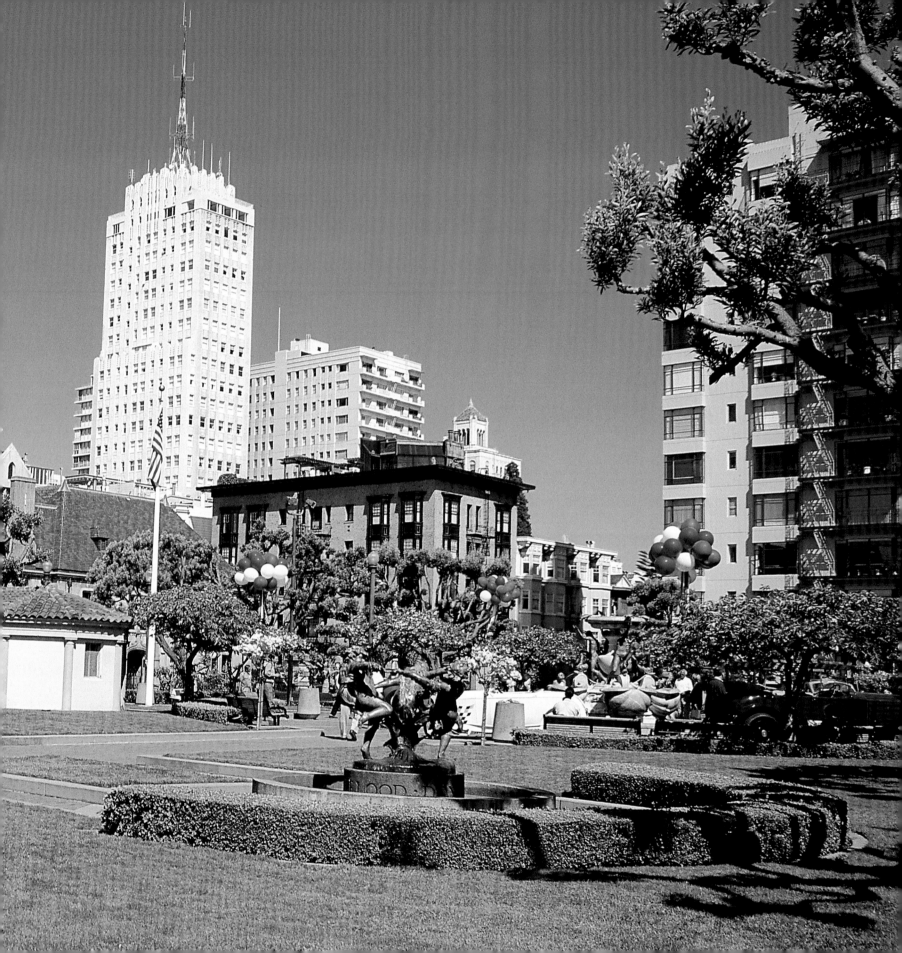

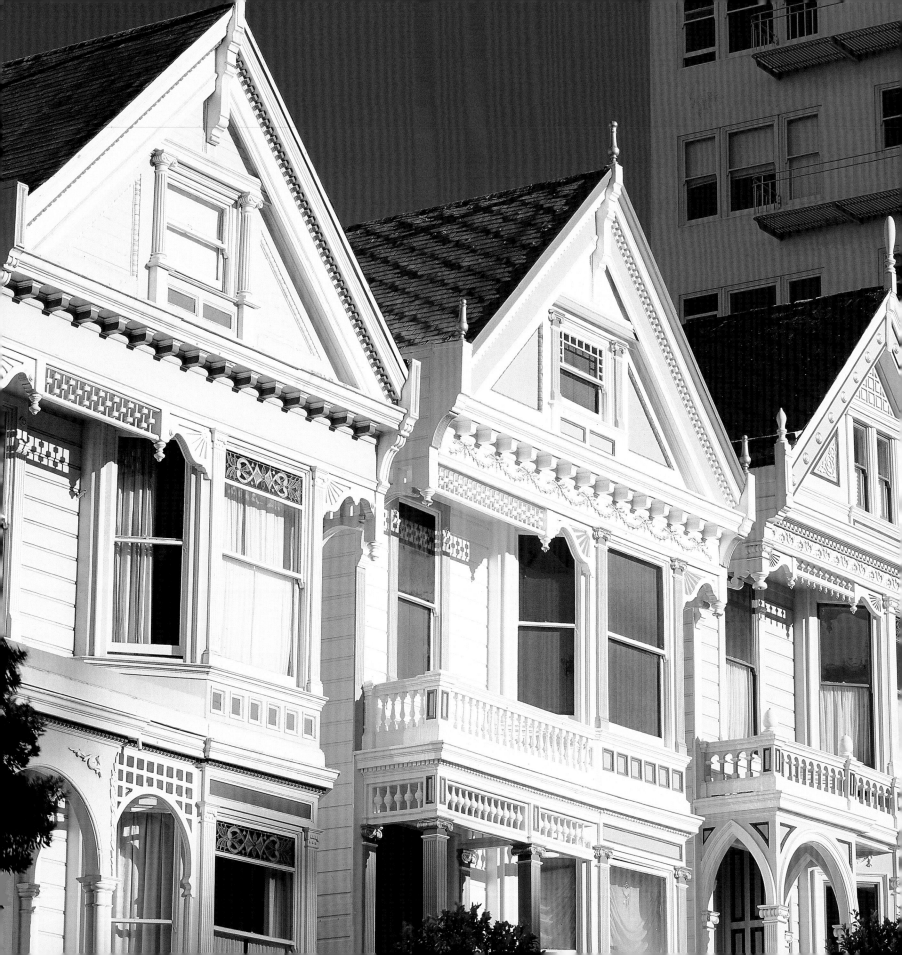

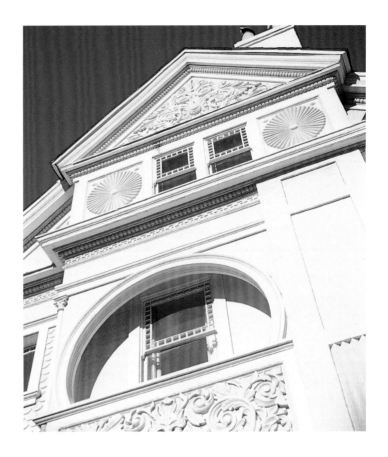

The upscale mansions that line Lafayette Square were first built here in the late nineteenth century by well-to-do families eager to compete with their Nob Hill counterparts. Many mansions were salvaged or rebuilt after the 1906 fire.

In the late 1800s and early 1900s, local families built tens of thousands of Victorian homes. Many survived earthquakes and city development, but succumbed to Depression-era gray paint and siding. The 1960s brought a rebirth of color, and homeowners refurbished the "painted ladies," such as these ones at Alamo Square.

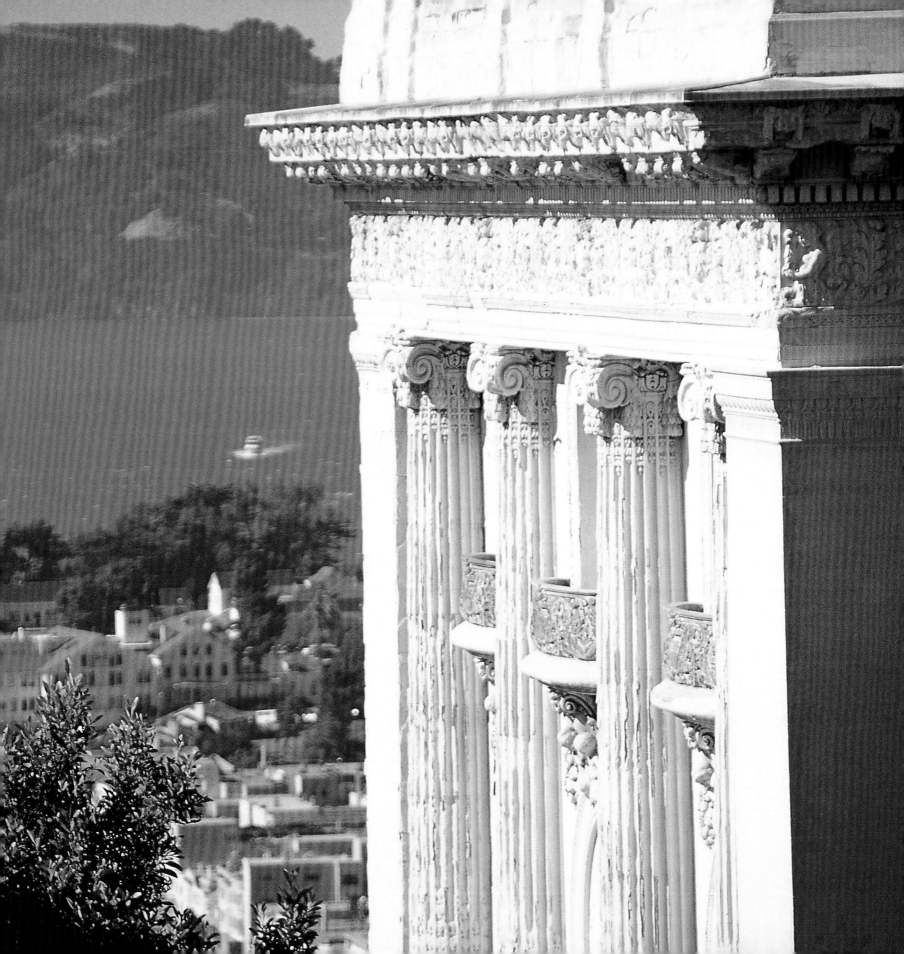

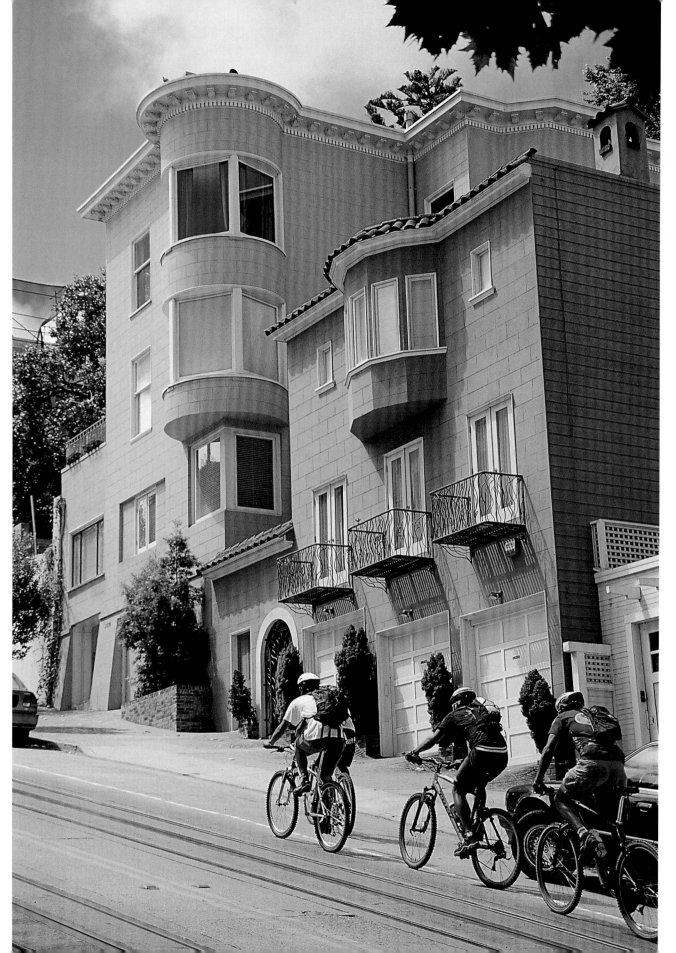

Bike commuters lead a difficult life on the hills of San Francisco. Nonetheless, the number of people who ride to work continues to grow, and the city is slowly establishing more bike lanes and cyclist-friendly routes.

FACING PAGE–
Views of San Francisco Bay are part of what makes Pacific Heights an elite enclave. While many remain private homes, some of the area's mansions have been reborn as schools, embassies, and posh condominium complexes.

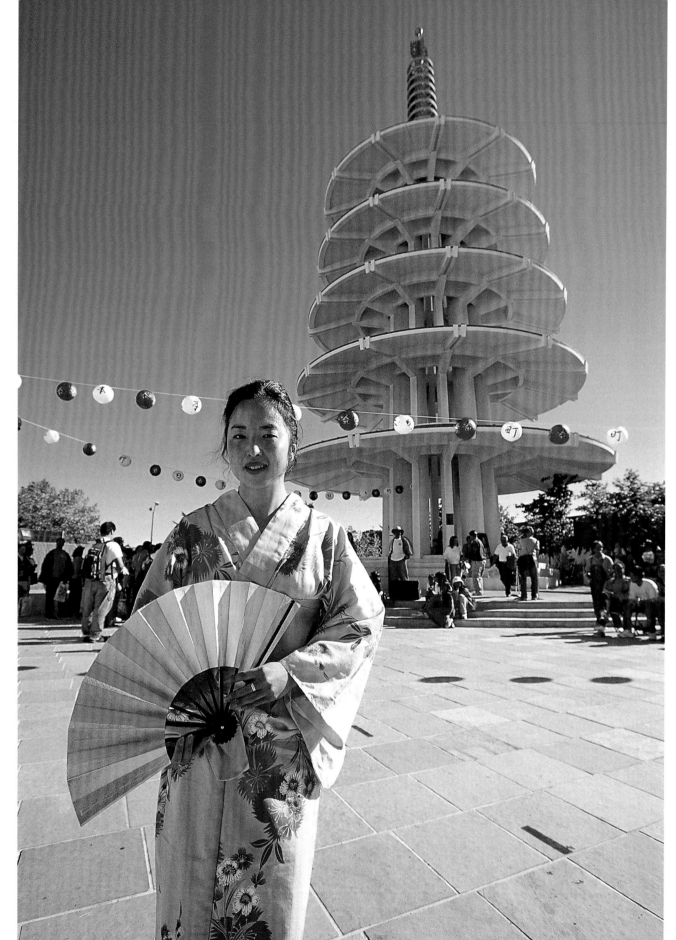

A gift from the people of Japan, the seven-tiered Peace Pagoda stands in Japan Center, crowning a five-acre collection of shops and restaurants. From tea and sushi to silk and modern art, visitors find an array of the traditional and the surprising.

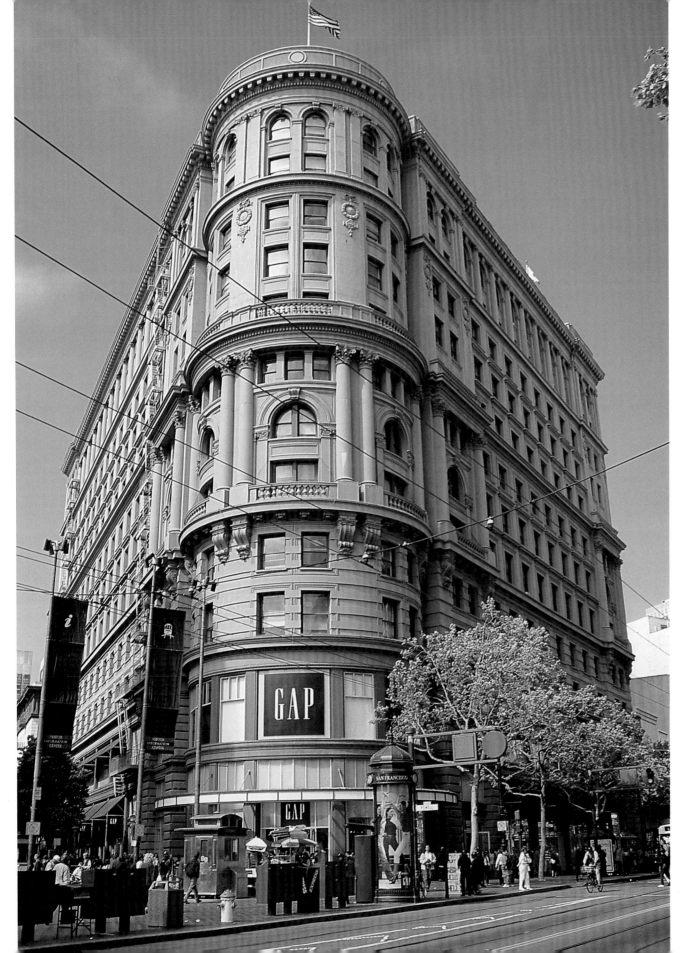

Market Street runs through the heart of San Francisco, from the funky Castro area, past City Hall to the Financial District. The street is served by the longest heritage streetcar line in the world—30 vintage cars carrying up to 20,000 riders each day.

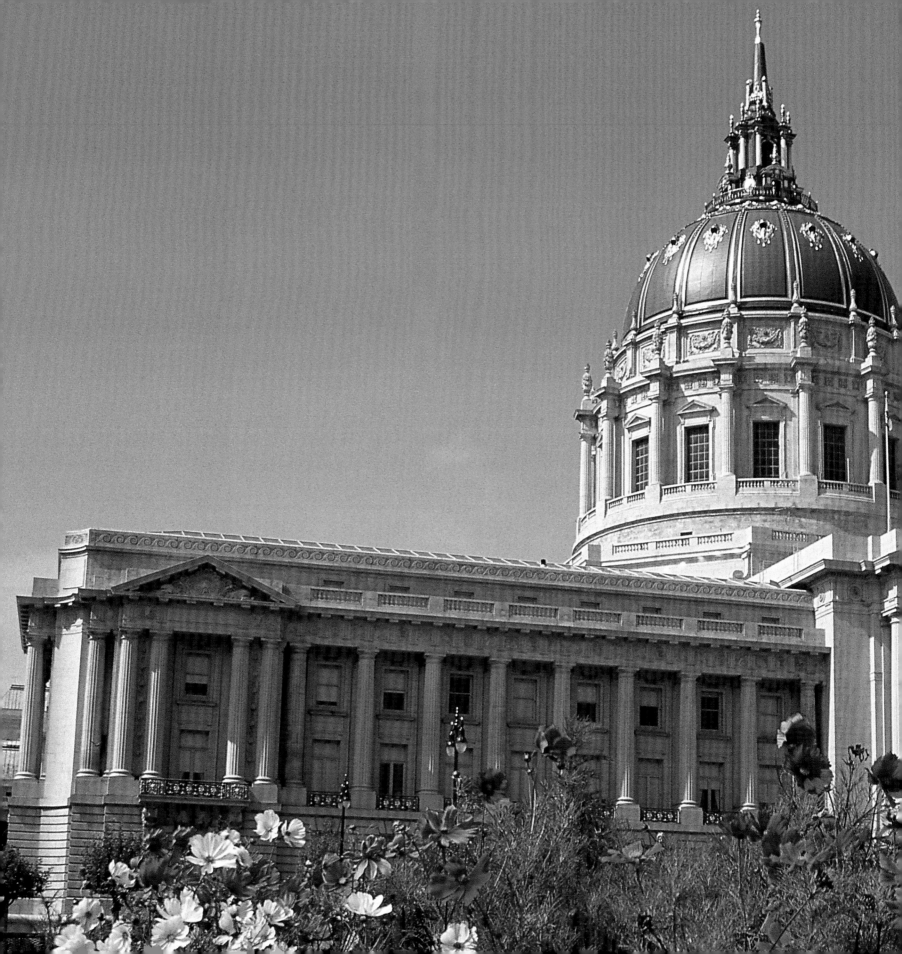

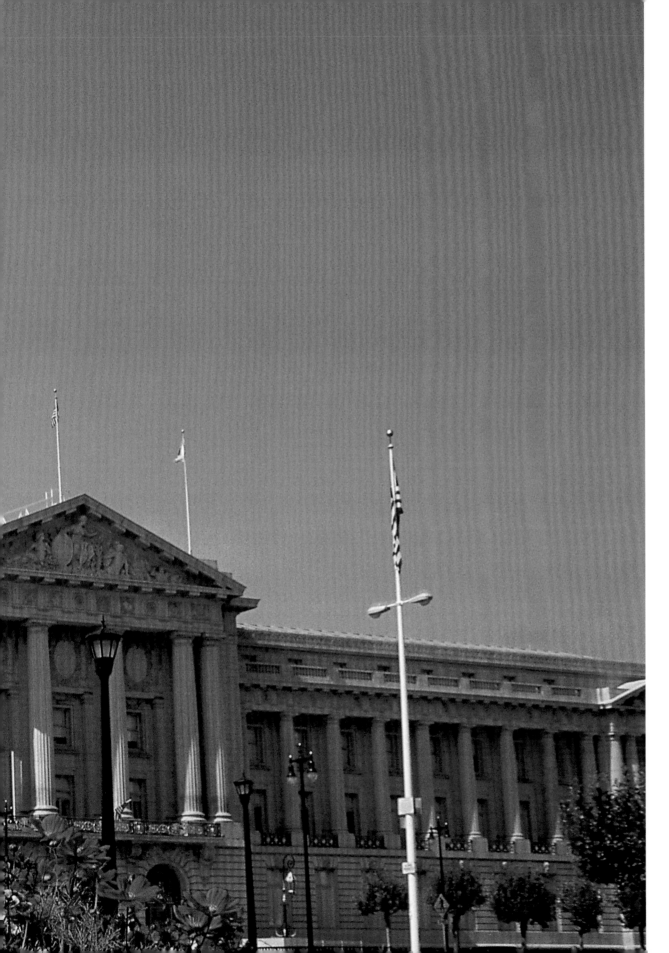

Designed by Arthur Brown, Jr., and opened in 1915, San Francisco's City Hall encompasses 500,000 square feet and is crowned by a 306-foot-high dome, one of the largest in the world. Inside, gilded cage-style elevators, crystal chandeliers, and a polished grand stairway serve as elegant reminders of the past.

Previously the site of
a U.S. Army prison,
Alcatraz Island became
a civilian penitentiary—
one of the most notorious
in the world—in 1934.
America sent its most
dangerous criminals
to the island, includ-
ing gangster Al Capone,
bank robber George
"Machine Gun" Kelly,
and Robert Franklin
Stroud, better known as
the Birdman of Alcatraz.

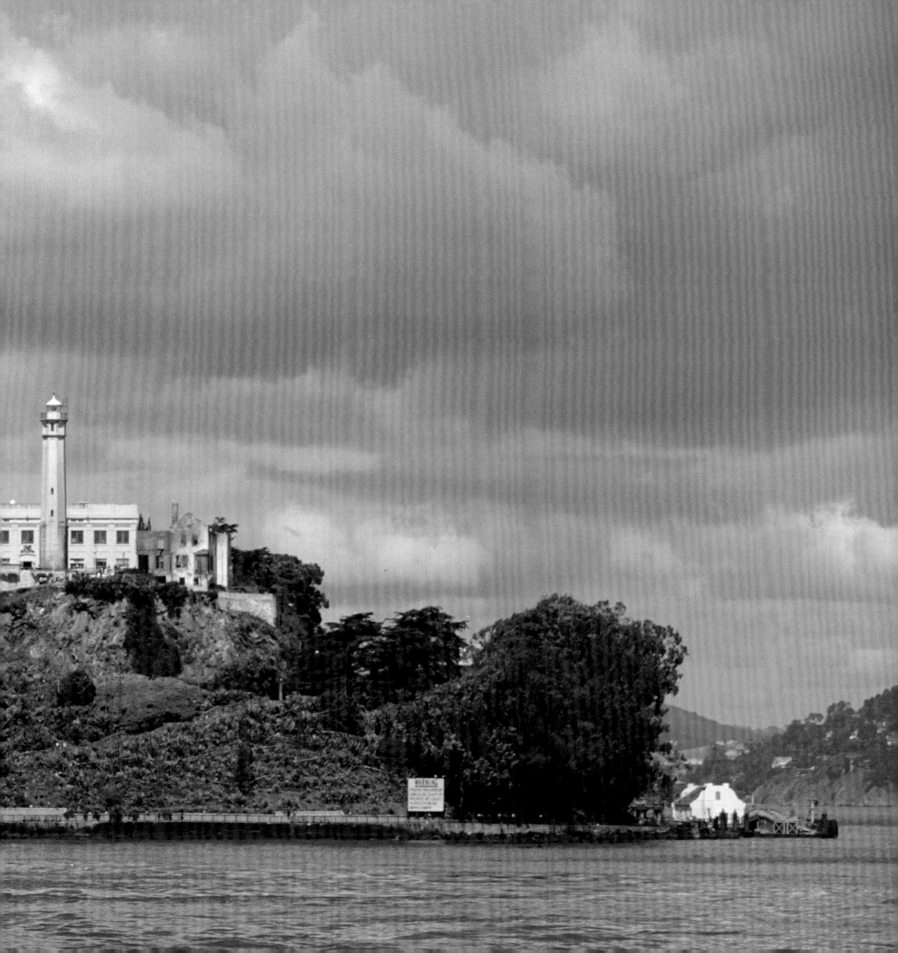

Visitors tour one of the cell blocks in Alcatraz. Thirty-six prisoners attempted to escape from the penitentiary. Seven were shot, two drowned, and 22 were caught. The other five escaped, but it is a mystery whether they reached the mainland alive.

FACING PAGE—
The warden's house sits perched above the sea cliffs of Alcatraz Island. Throughout the prison's existence, the press received reports and rumors of prisoners driven insane by the conditions of Alcatraz. Attorney General Francis Murphy called it a "horror spot" in 1939 and promised to close it, but the prison remained in operation until 1963.

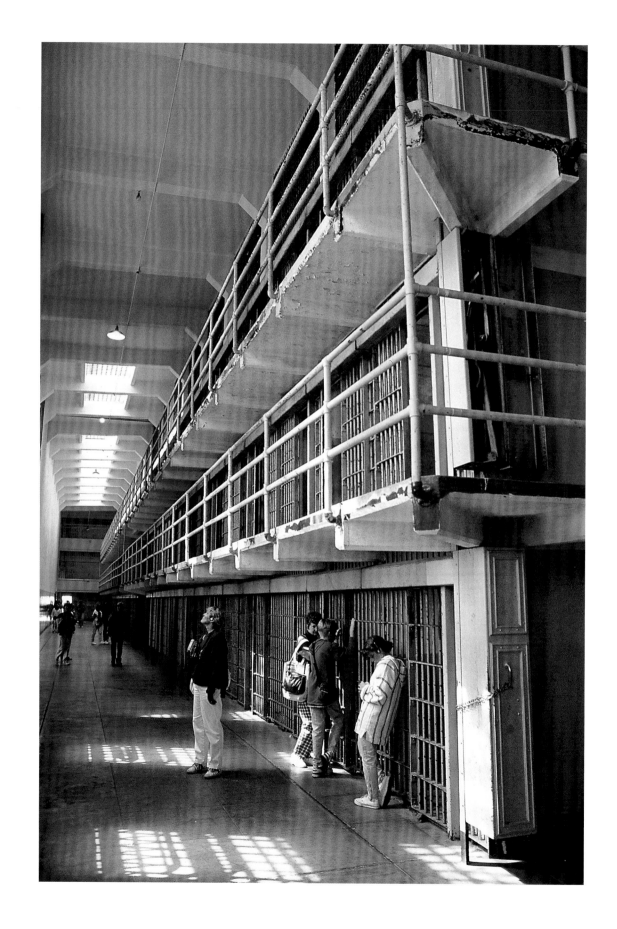

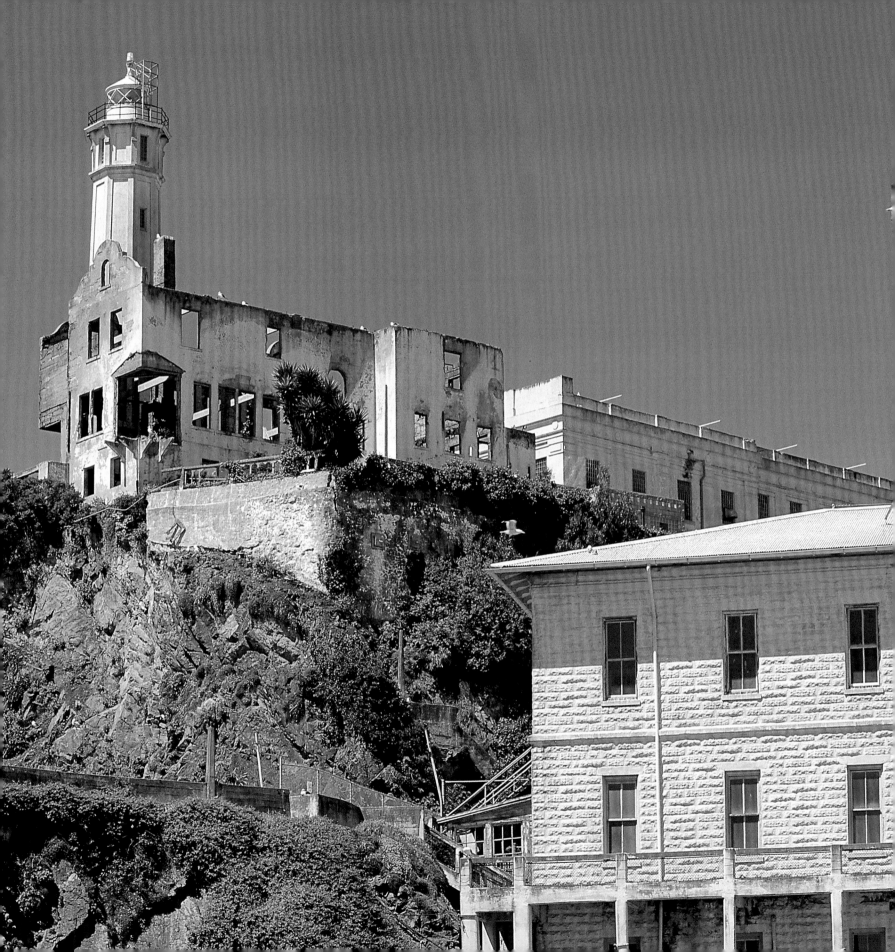

In the late 1800s, many of the fishermen who docked at Fisherman's Wharf were Italian. Working from small boats, each marked with the name of a patron saint, the men set out into the bay. Those on shore could sometimes hear them singing, to help orient each other in the fog.

When news of California's gold rush spread in the mid–1800s, ships from around the world began arriving in San Francisco. Today the harbor is shared by international freighters and recreational vessels.

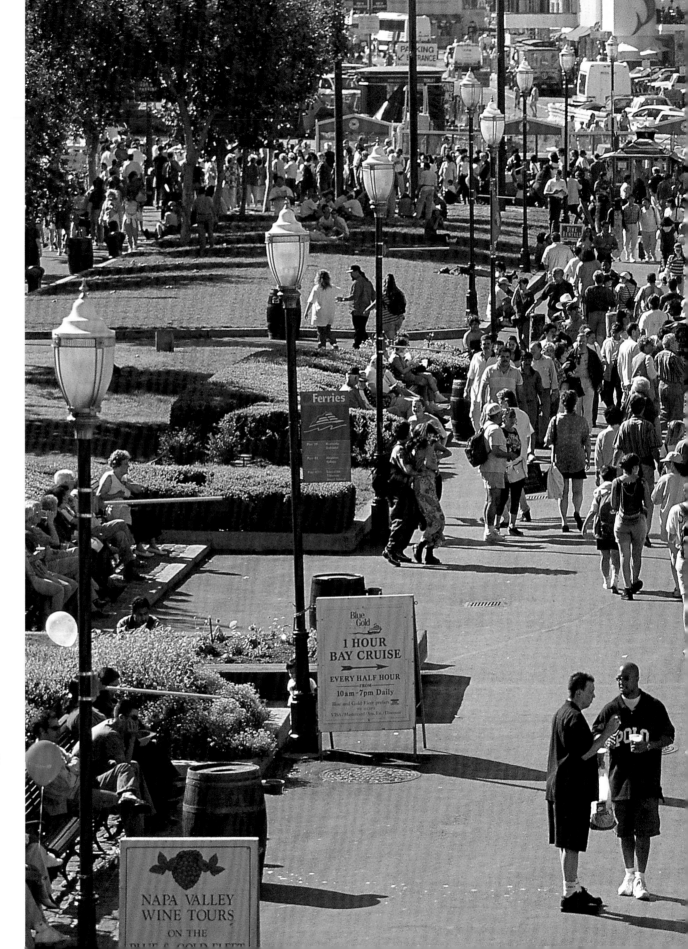

Almost all San Francisco visitors make Fisherman's Wharf part of their city tour. Fresh seafood vendors compete with souvenir sellers, while street performers, sea lions, and gulls all vie for attention nearby.

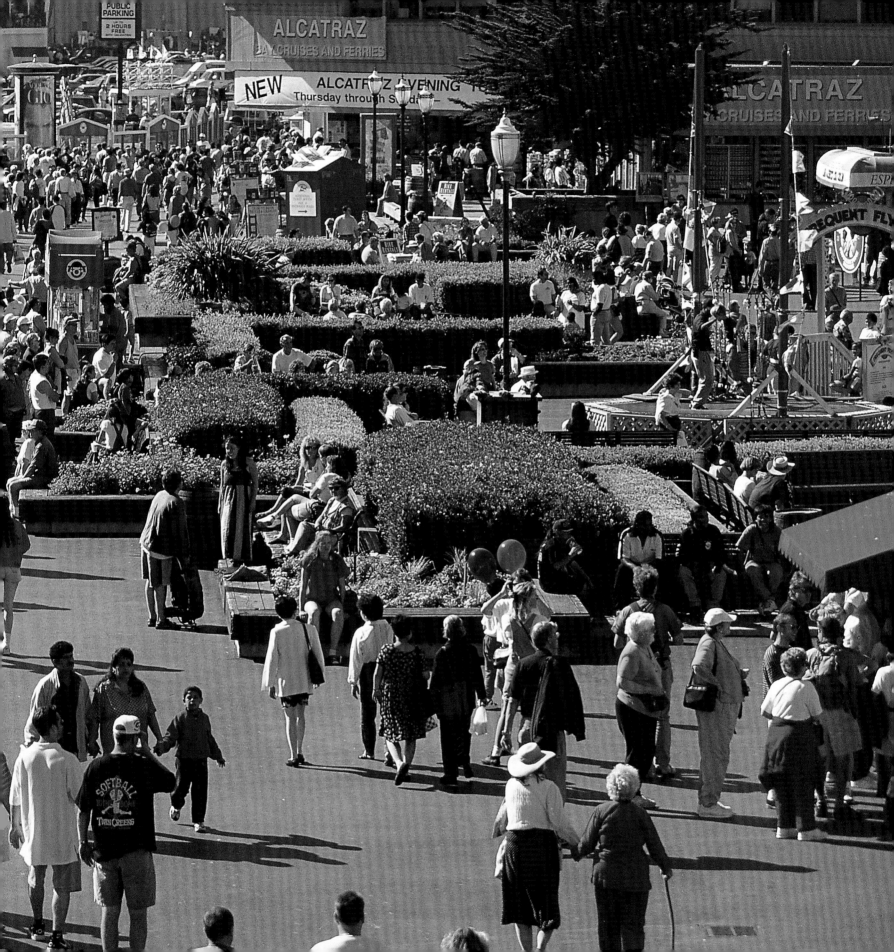

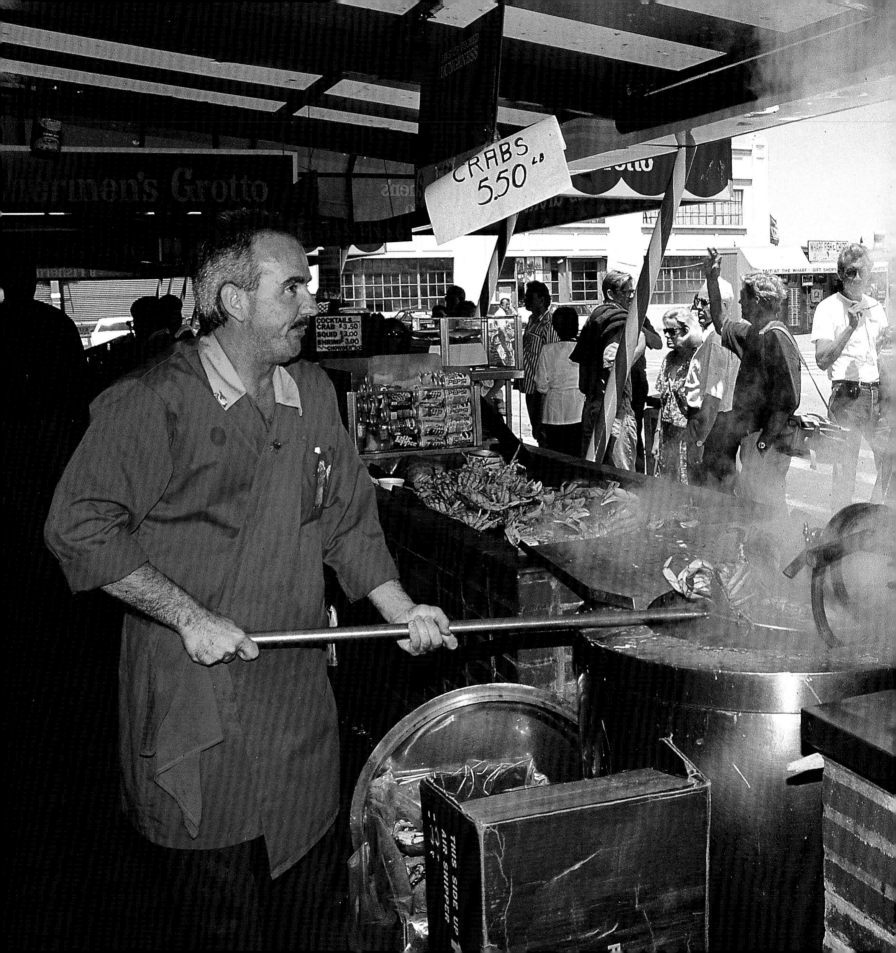

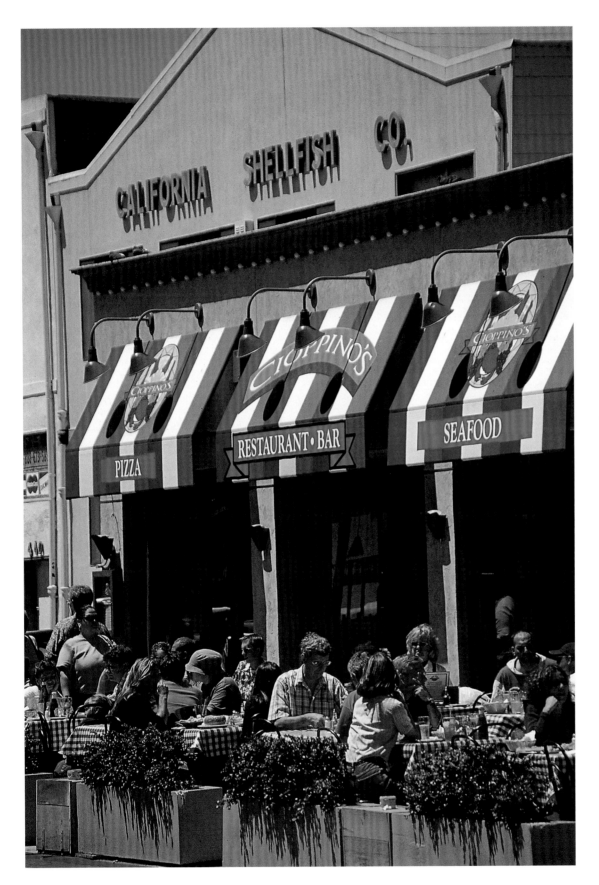

Mealtimes at Fisherman's Wharf can mean anything from street vendor snack foods to freshly sautéed shellfish. For many, clam chowder served in a sourdough bread bowl is the essential lunch choice.

FACING PAGE–
An entrepreneur presides over a steaming cauldron, offering whole cooked Dungeness crabs or paper cones of delicate crabmeat. With a loaf of the fresh bread sold nearby, this is a perfect picnic for a sunny afternoon at Fisherman's Wharf.

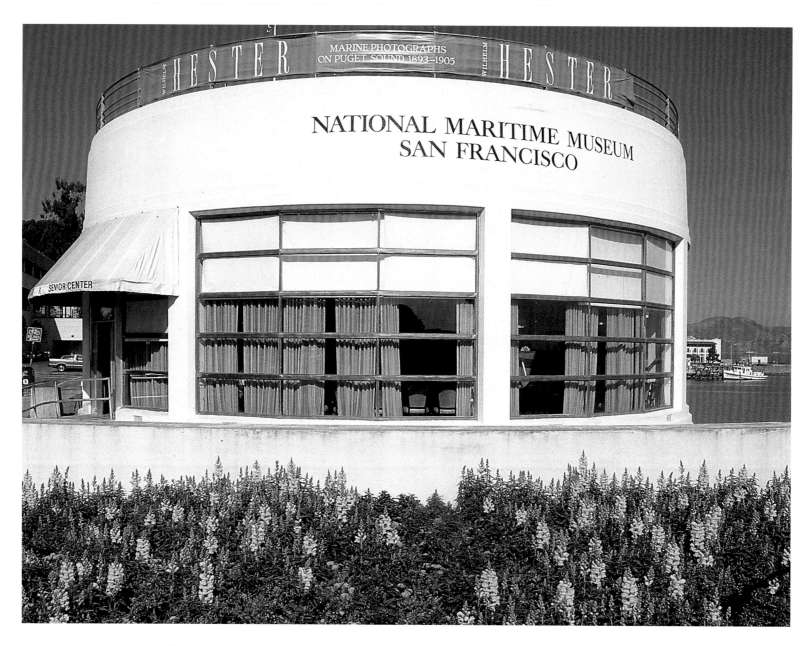

Inside the Maritime Museum, enthusiasts can test their boatbuilding skills, learn a little woodworking, sing a sea chantey, or learn about pirates on the Pacific. The museum is part of the San Francisco Maritime National Historic Park, which draws more than 3.3 million sightseers each year.

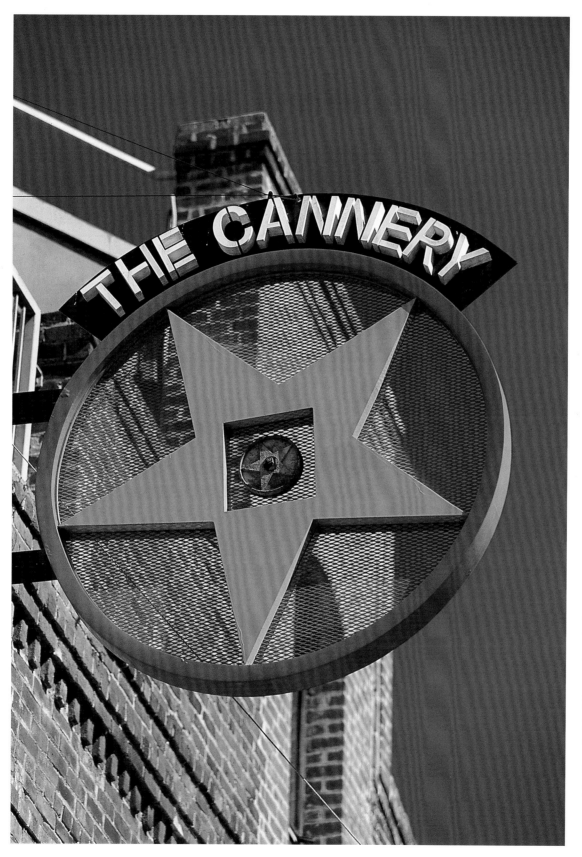

In the early 1900s, this was the largest peach cannery in the world, capable of producing 200,000 hand-sealed cans each day. The Depression ended its economic success and the building was destined for demolition in the 1960s. Fortunately, it was instead transformed into one of the city's most popular entertainment and retail complexes.

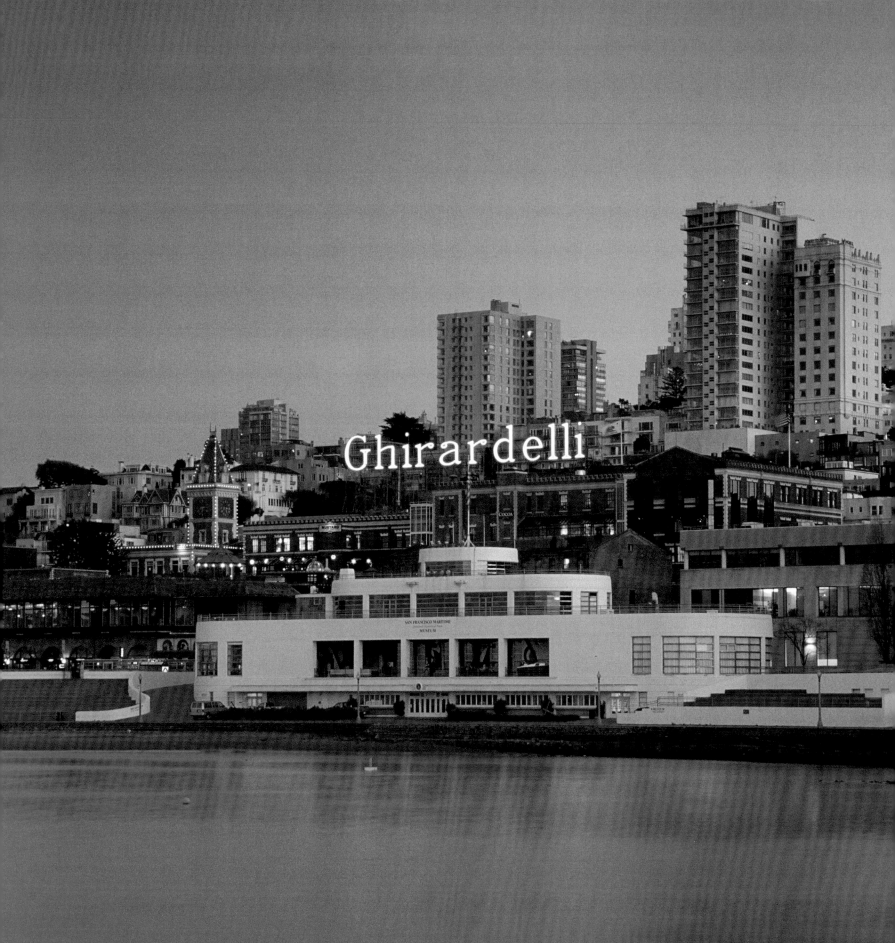

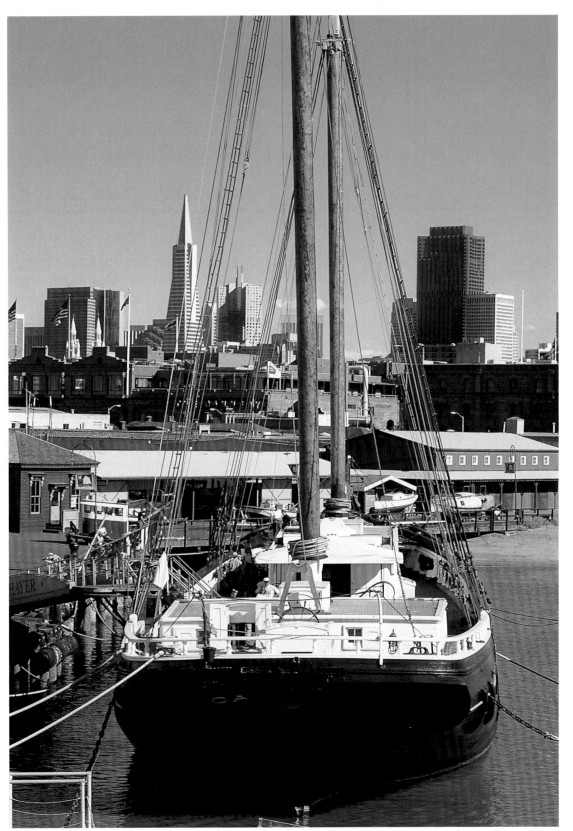

The historic vessels moored at Hyde Street Pier are protected by the San Francisco Maritime National Historic Park. From cargo ships that sailed to and from the ports of Europe to a steam-powered tugboat that once chugged along the coast, these vessels provide authentic glimpses of past days on the water.

FACING PAGE—
Italian-born confectioner Domenico Ghirardelli was drawn to California by news of the gold rush. Around 1850, he opened his first store in a tent. In the 1860s, the company imported 1,000 pounds of cocoa beans annually; by 1885, that number grew to 450,000. Ghirardelli Square was built to house the company's booming operations in the early 1900s.

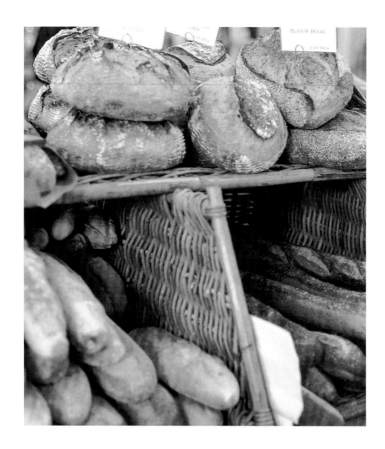

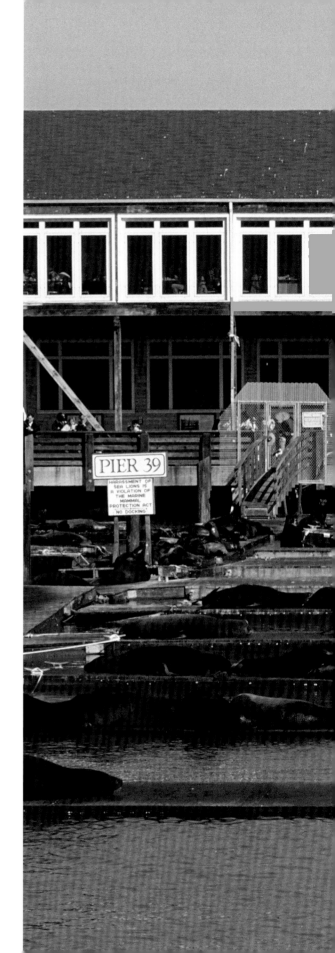

While this city bakery provides every imaginable loaf, San Francisco is best known for its sourdough. The San Francisco French Bread Company, an amalgamation of three area bakeries founded in the nineteenth century, now produces 2 million loaves of sourdough and French bread each week.

Sightseers visit Pier 39 for the people-watching as much as the wildlife. These California sea lions arrive to feast on the herring and to bask in the sunshine—900 animals winter here, and a few stay year-round. They have taken over what was once a working pier, but since visitors arrive specifically to see them, the city has allowed them to stay.

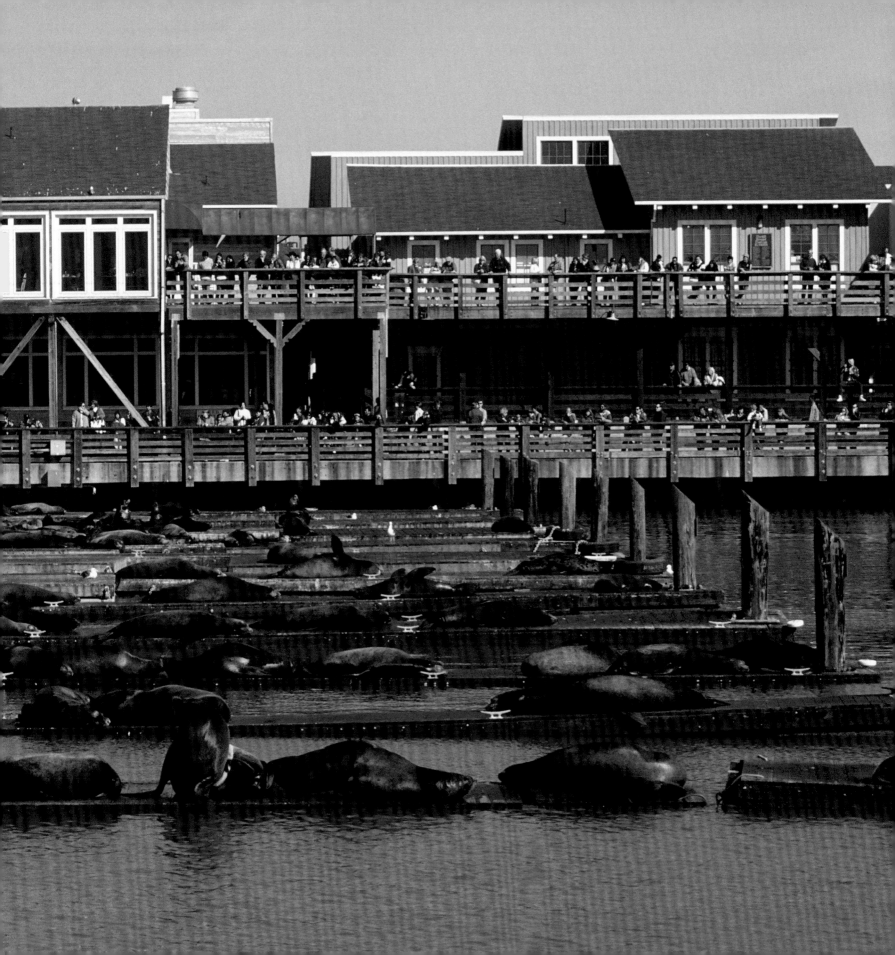

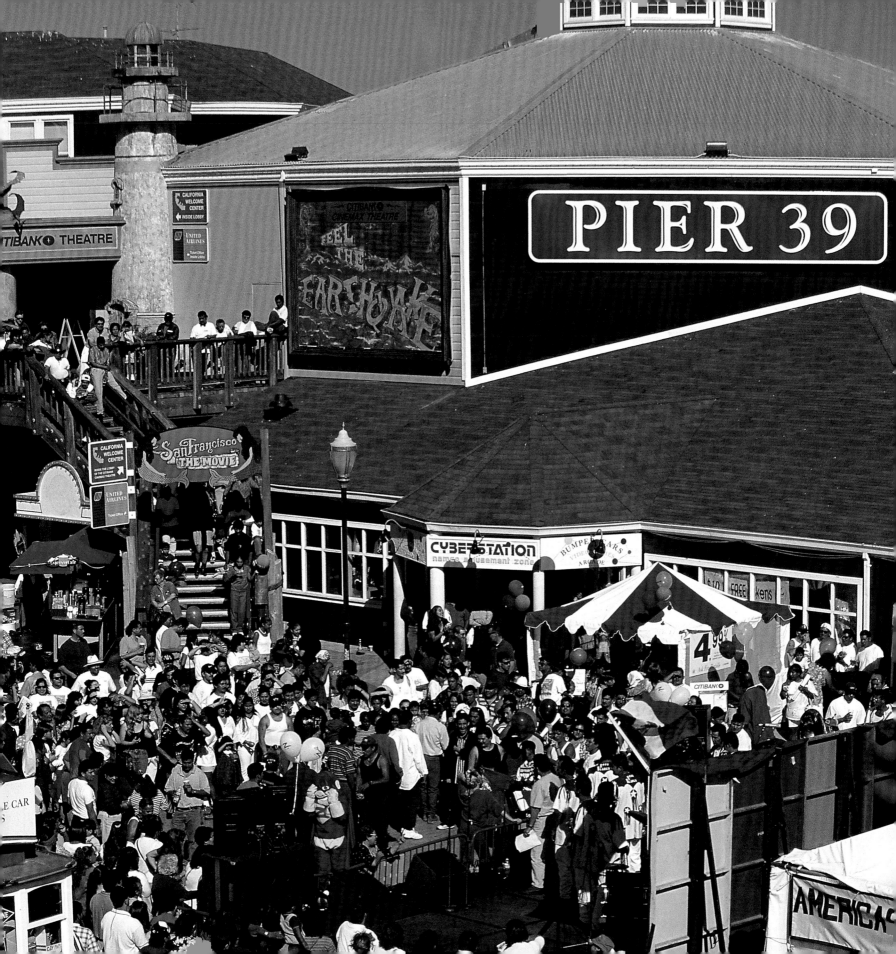

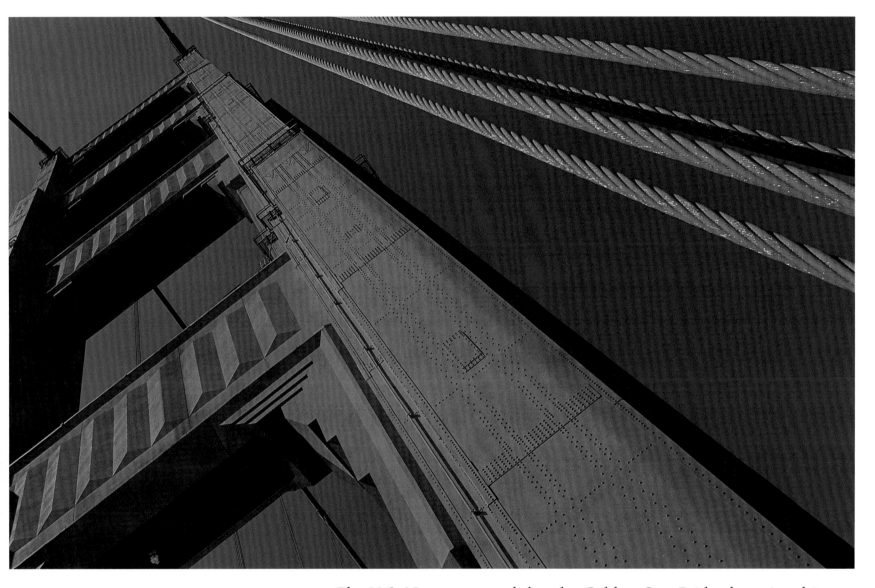

The U.S. Navy suggested that the Golden Gate Bridge be painted in black and yellow stripes to warn approaching ships. Architect Irving Morrow chose international orange instead, to complement the bridge's natural surroundings.

At San Francisco's northernmost point, Pier 39 provides endless entertainment. More than 100 retail shops, restaurants and food vendors, street performers, boat charters, a Venetian carousel, an aquarium, a theater, and adventure rides keep visitors of all ages busy from sunup until after sundown.

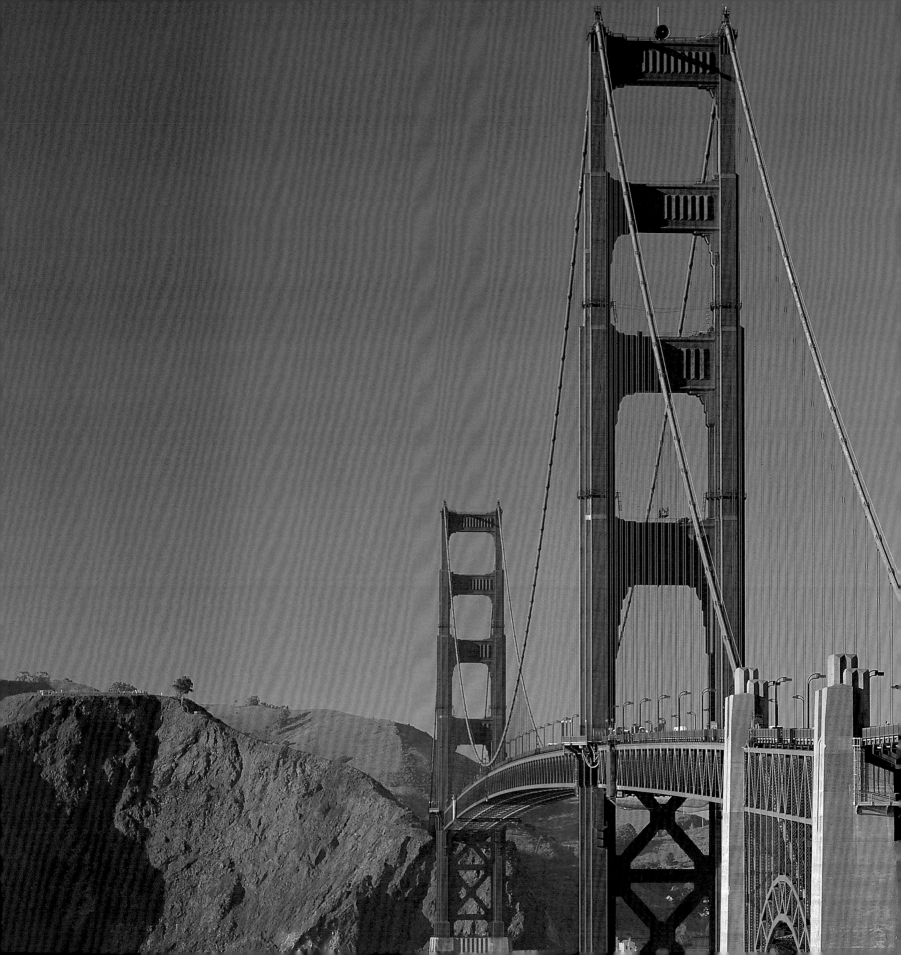

Construction of the Golden Gate Bridge began on January 5, 1933. When it was completed four years later, the 4,200-foot span was the longest suspension bridge on earth. Although it has since been surpassed, the Golden Gate remains an architectural landmark recognized around the world.

57

For residents, the Golden Gate Bridge is as much a commuting necessity as a national landmark. For tourists, the bridge is an opportunity for adventure—a challenging climb up the steps near Fort Point and a windy 1.7-mile pedestrian crossing.

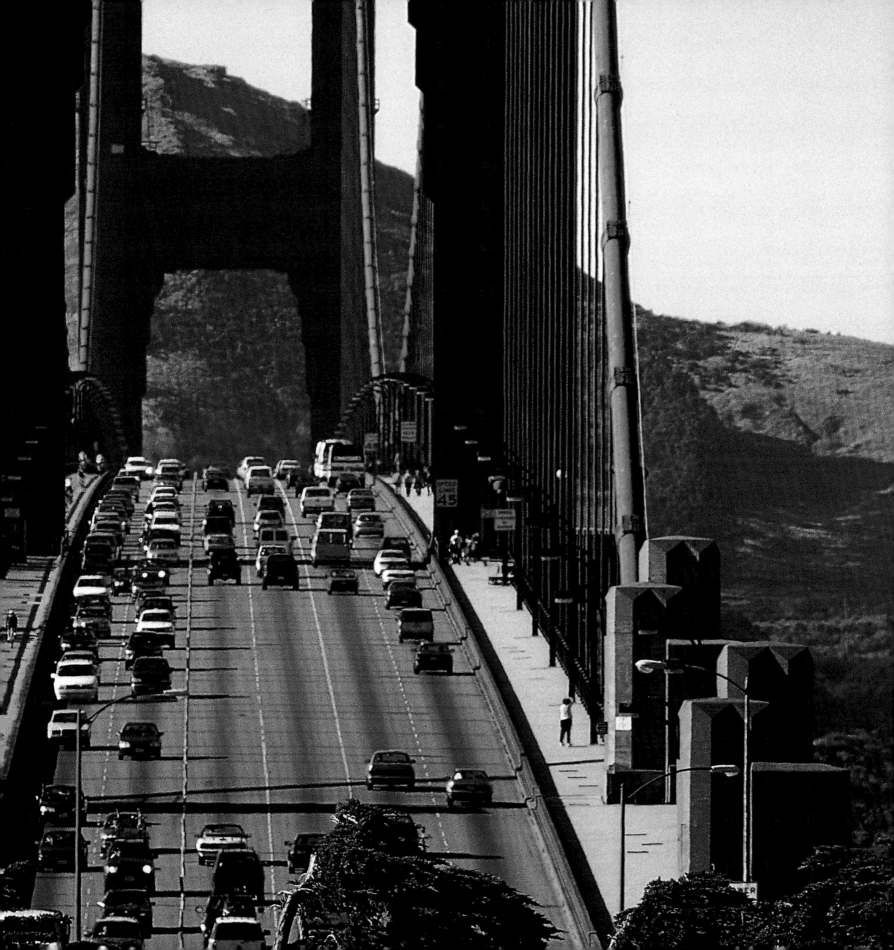

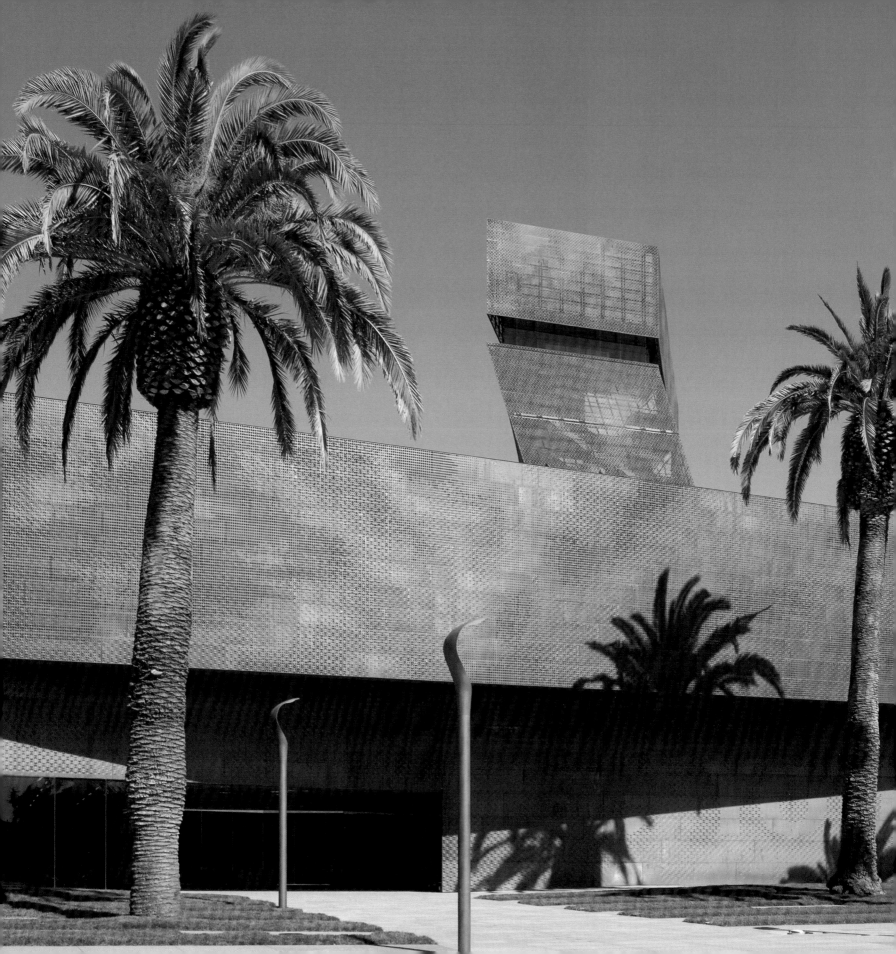

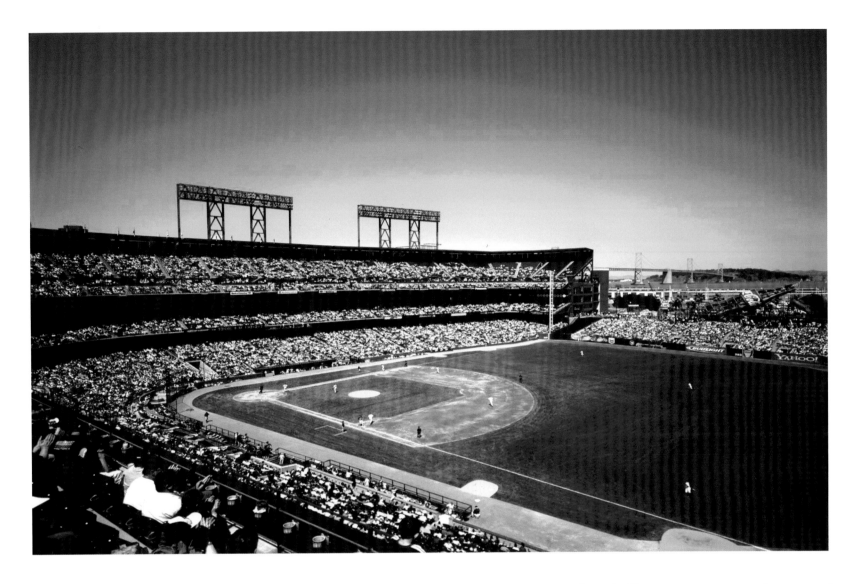

Home to the San Francisco Giants baseball team, AT&T Park opened in 2000 and seats more than 41,000 fans. About 500 feet from home base, a 66-foot-high baseball glove challenges major league hitters. The stadium and surrounding residential and commercial buildings and marinas were constructed in the so-called China Basin neighborhood, formerly an industrial area.

Founded in 1895 in Golden Gate Park, the de Young Museum houses a priceless collection of American and international art. The new facility, which opened in 2005, was designed by Swiss architects Herzog & de Meuron and the local firm Fong & Chan.

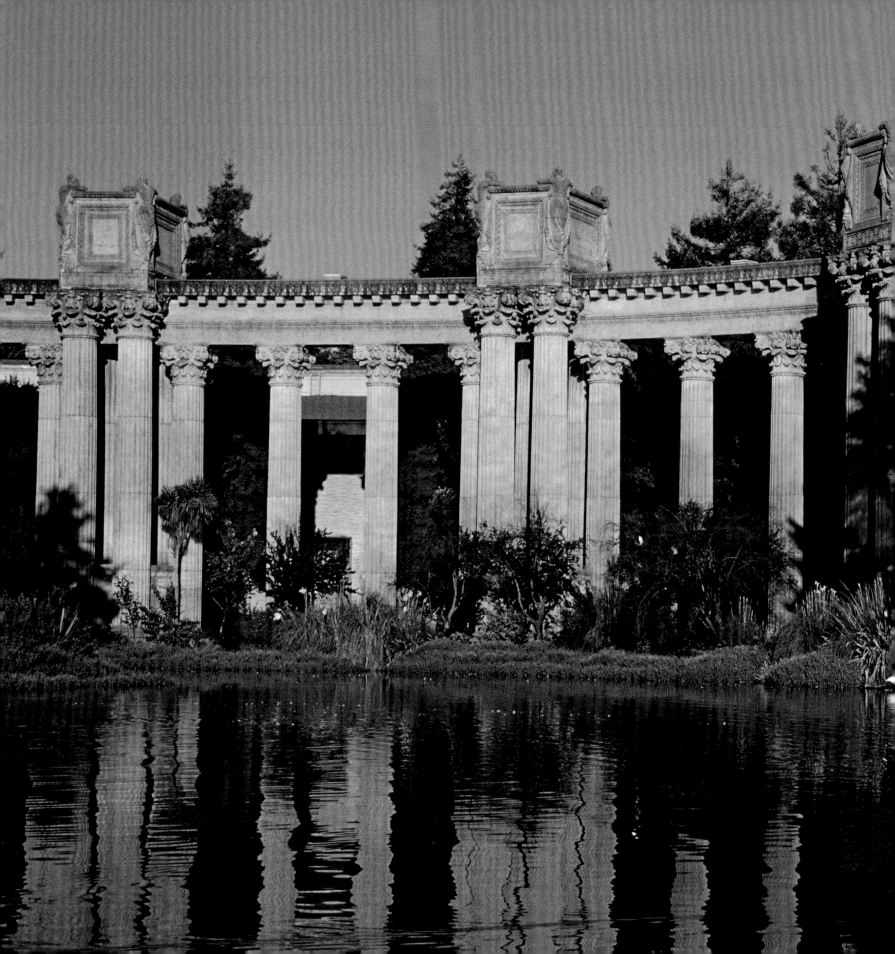

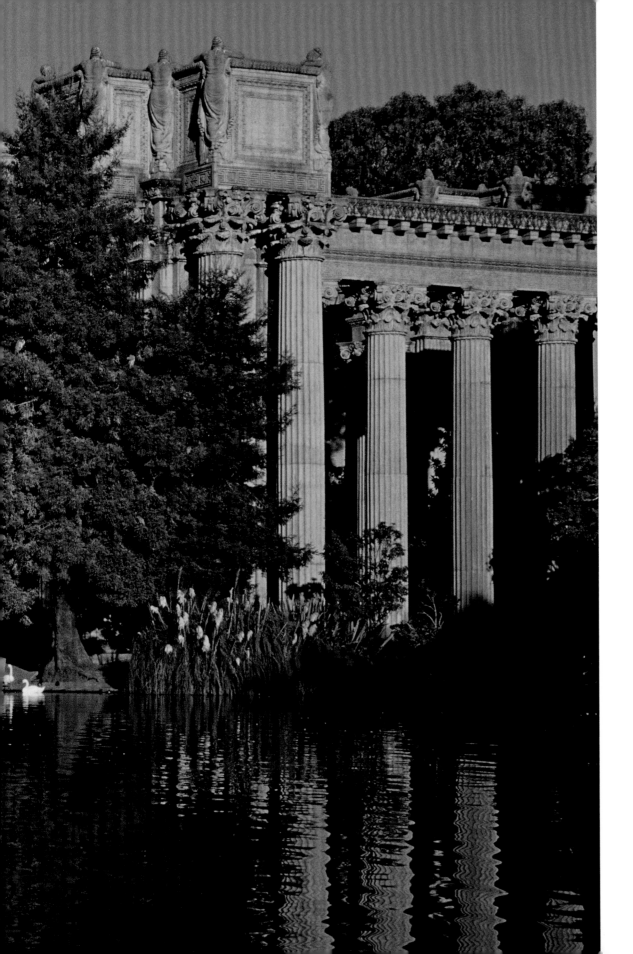

In 1915, San Francisco hosted the Panama Pacific International Exposition, a world's fair designed to celebrate the opening of the Panama Canal and showcase San Francisco's recovery from the 1906 earthquake. Architect Bernard R. Maybeck designed the Palace of Fine Arts, one of the fair's central attractions.

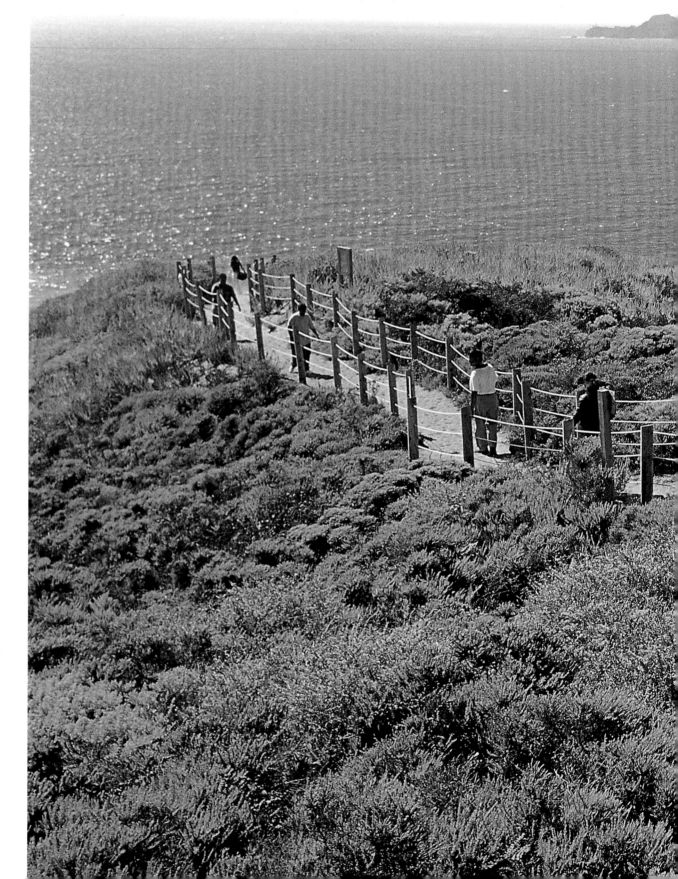

Trails in the Presidio, part of Golden Gate National Recreation Area, lead down the bluffs to Baker Beach. There, views of San Francisco Bay and the Golden Gate Bridge are the main attractions. Much of the surrounding 1,400 acres served as a military base for more than two centuries, hosting Spanish, Mexican, and finally American forces.

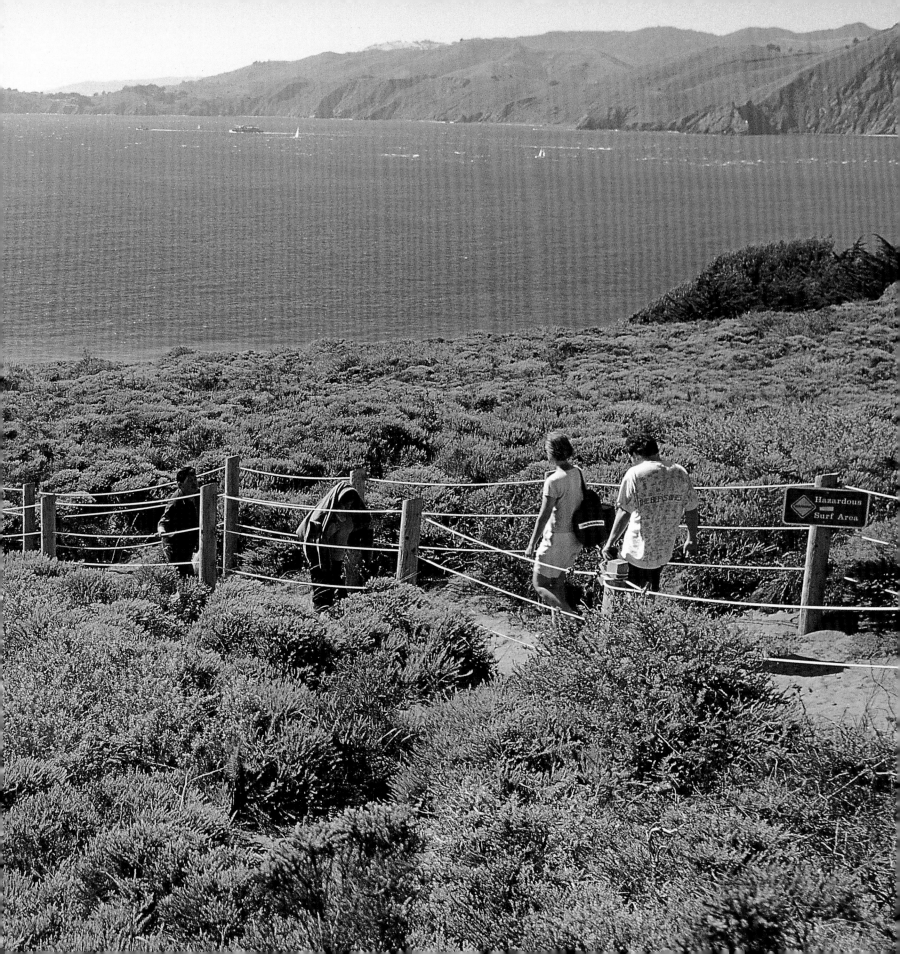

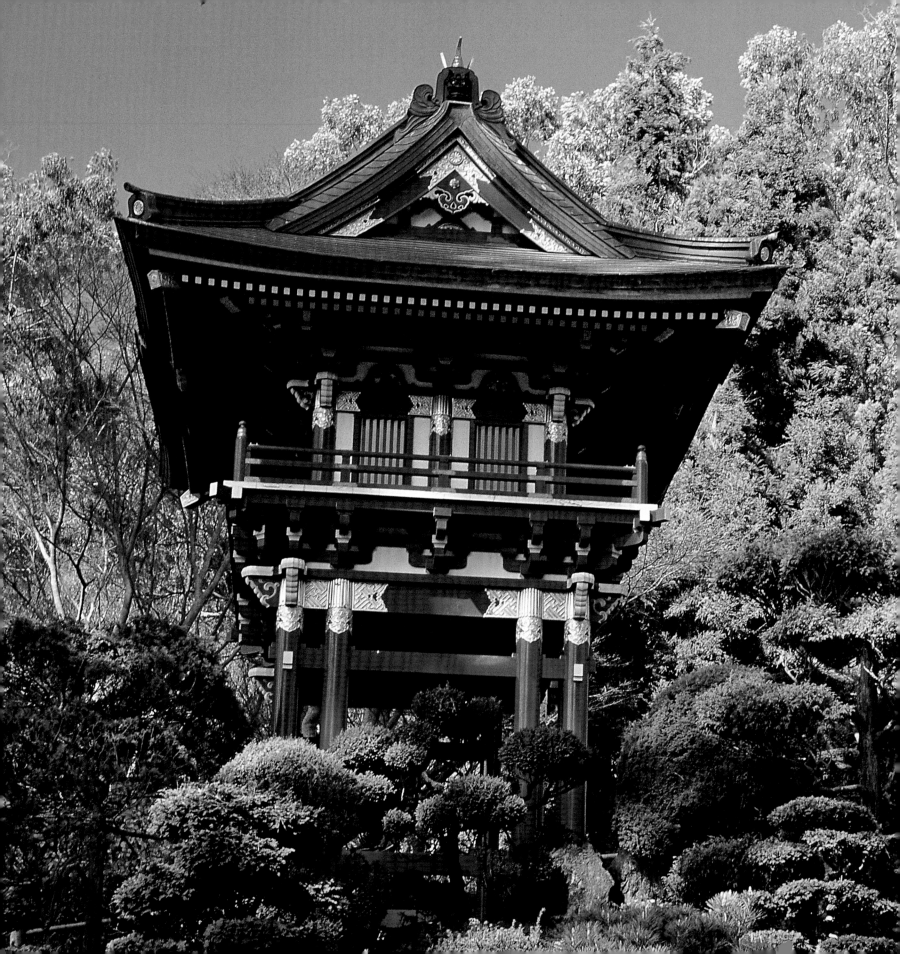

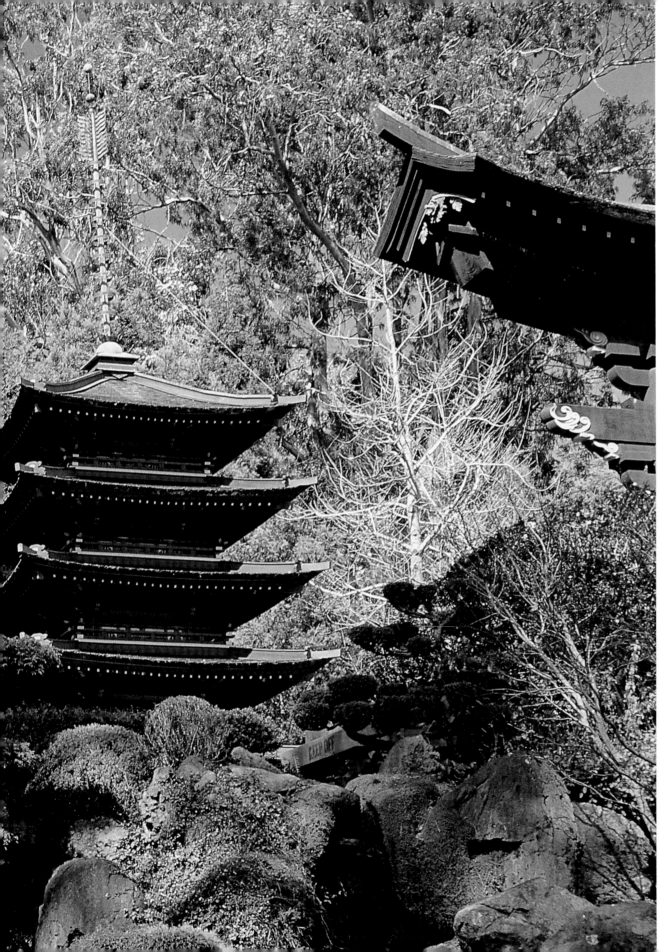

Workers tamed and landscaped the existing sand dunes to create Golden Gate Park in the 1870s. Today the preserve includes sports facilities, walking and cycling trails, an arboretum, and this serene Japanese Tea Garden. Some of the garden's structures were built in 1894, making this the oldest Japanese garden in California.

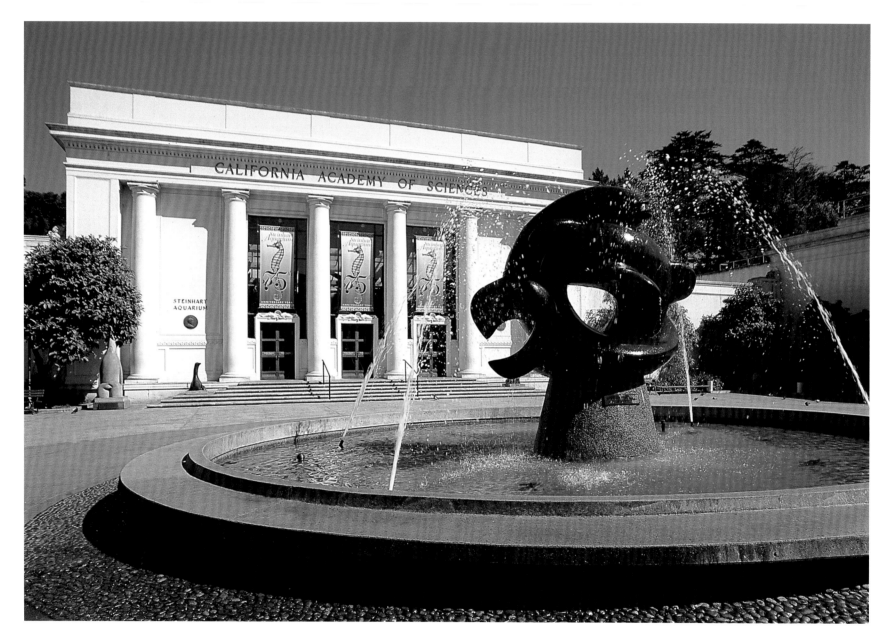

Within Golden Gate Park, the California Academy of Sciences includes an aquarium, a natural history museum, and a planetarium, allowing visitors to explore earth, ocean, and space in a single visit. When it was founded in 1853, this was the first scientific institution on the West Coast.

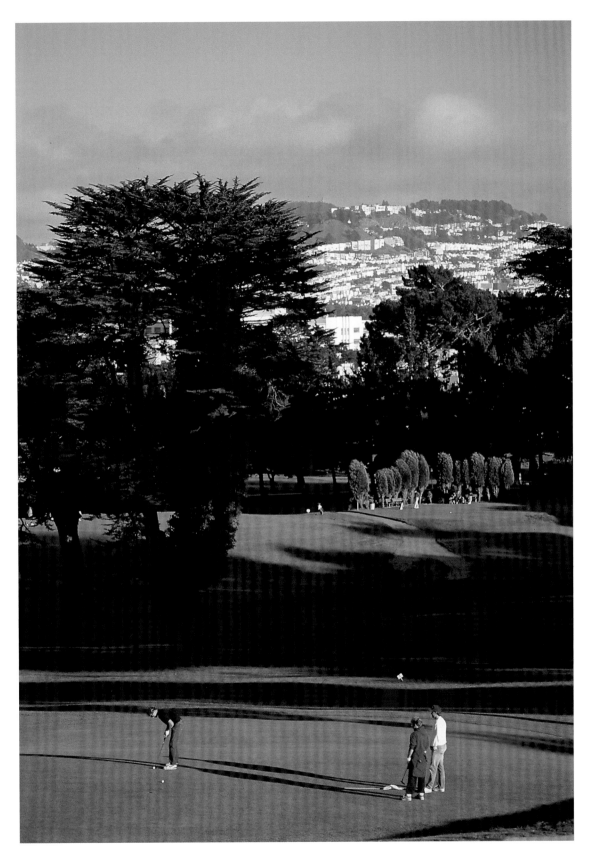

Sunny afternoons find enthusiasts enjoying a quick round at Lincoln Park Golf Course. Though certainly not the most challenging or the most exclusive of San Francisco's courses, Lincoln Park offers unmatched views of the Pacific and the city skyline from many of its 18 holes.

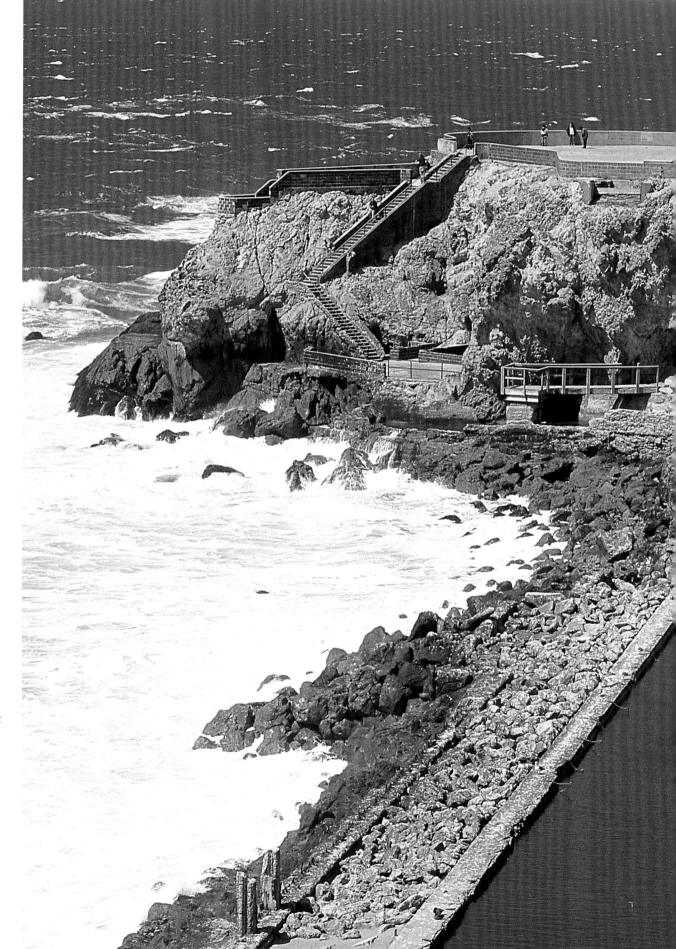

Built in 1886 by developer Adolph Sutro, the Sutro Baths once offered 25,000 people a day a chance to soak in one of six glass-enclosed pools. The complex is now protected by the Golden Gate National Recreation Area.

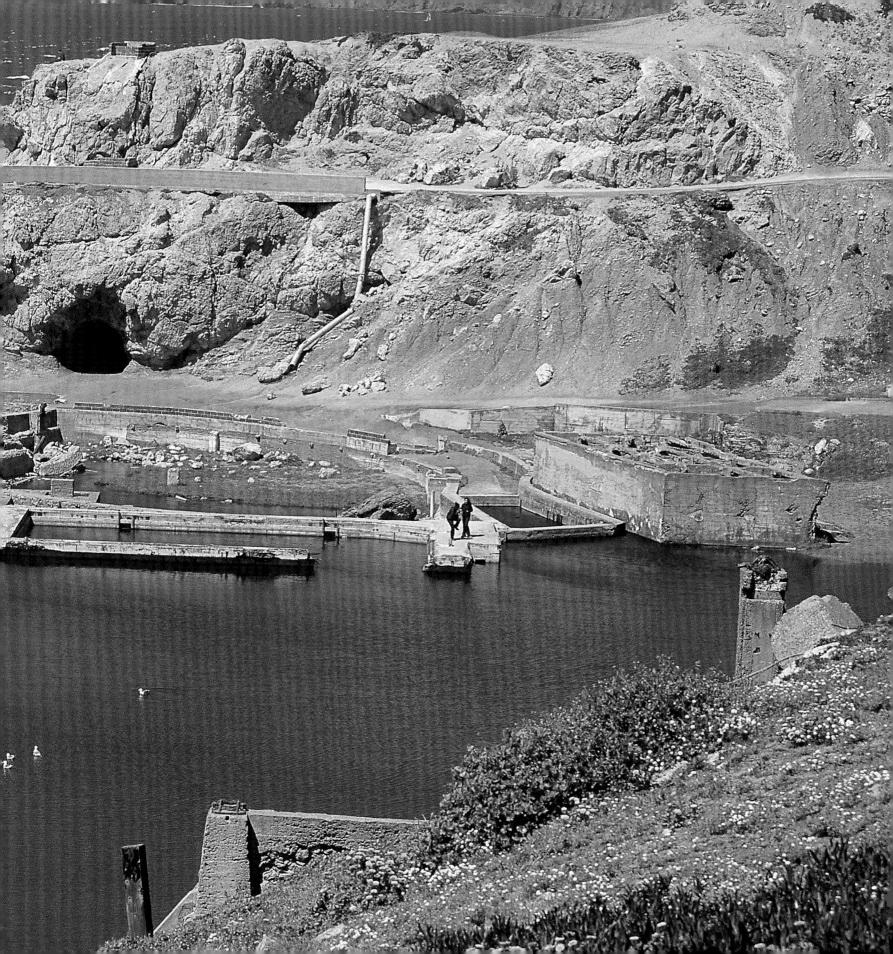

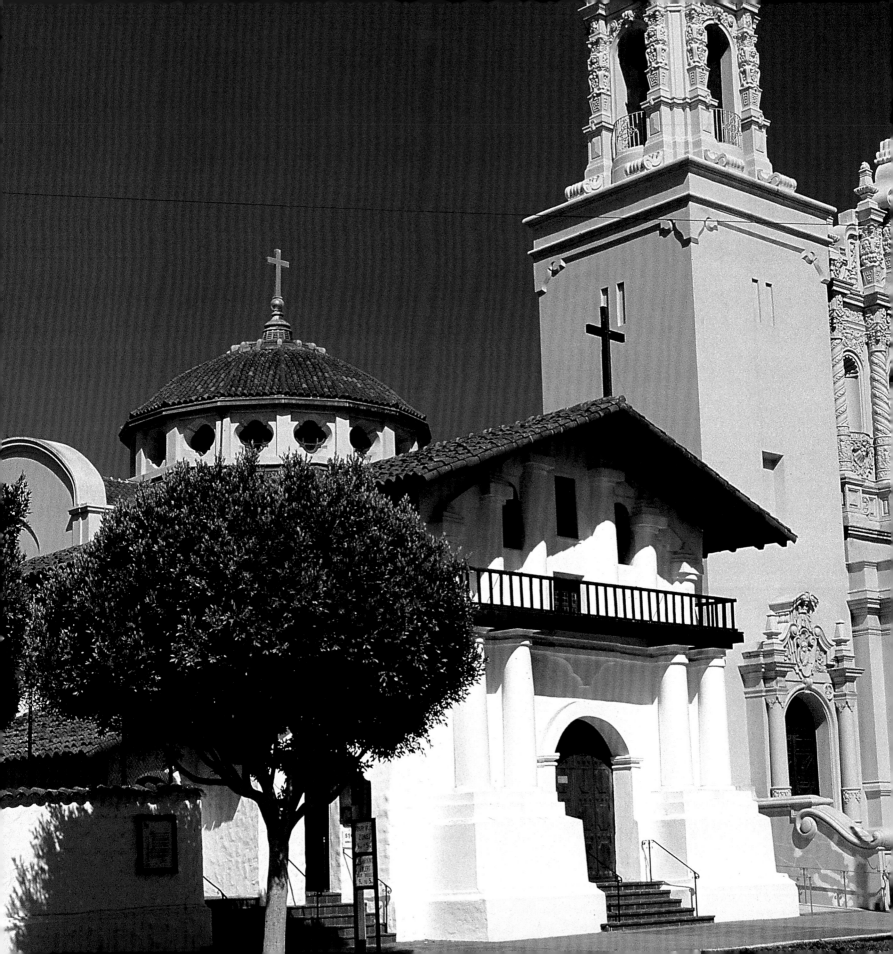

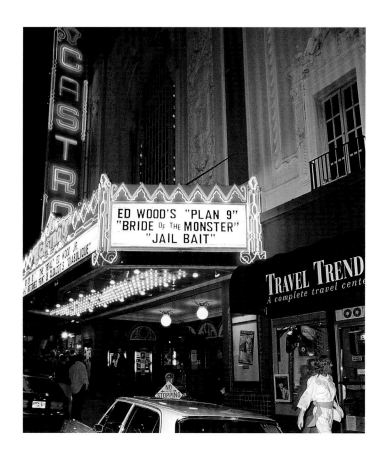

The Castro attracted an influx of gay men in the 1970s and has since become one of the world's most famous gay districts. Flocks of pedestrians crowd the sidewalks, weaving past brightly decorated Victorian homes, curio shops, diverse eateries, and lively night spots.

When Russian sailors began exploring the Pacific coast in the 1700s, Spain decided to solidify its claim on California. Soldiers and priests were sent north from Mexico to establish a fort and mission near the shores of San Francisco Bay. Built in 1776, Mission Delores is the oldest surviving structure in San Francisco.

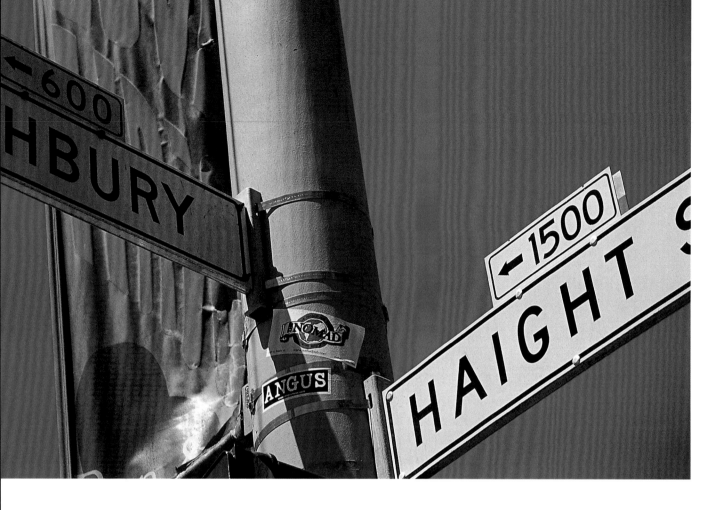

The birthplace of flower power, the corner of Haight and Ashbury is best known as a 1960s hippie haven. Here, the atmosphere still honors the age of the Grateful Dead, hallucinogenic drugs, and the Summer of Love.

In today's Haight, neo-punk record shops co-exist peacefully with chic nightclubs. Shoppers can find everything from retro tie-dyed pants, lava lamps, and incense burners to designer accessories and Internet access.

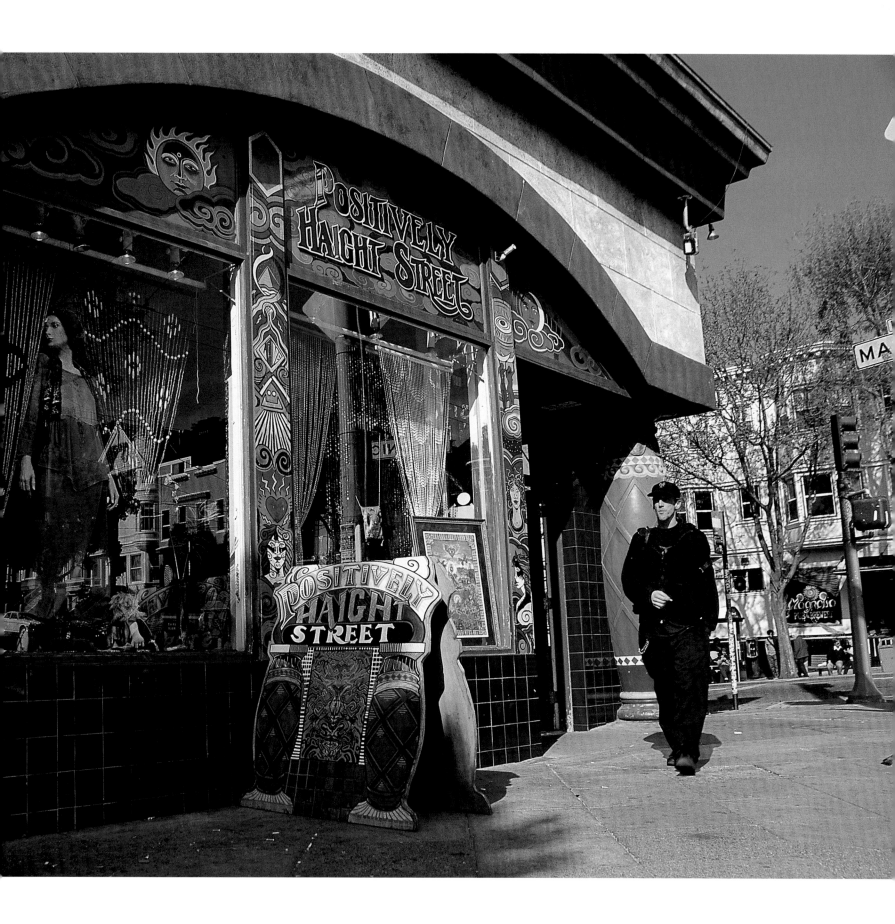

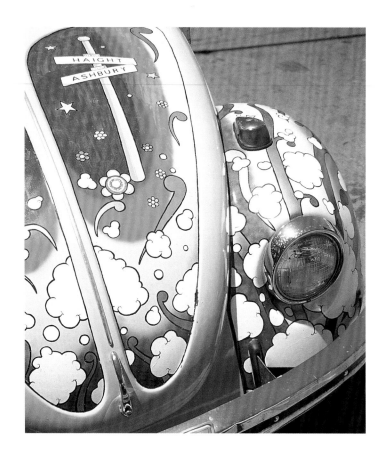

As this art car attests, many Haight residents embrace their neighborhood's counter-cultural past whole-heartedly. The local shops and cafés also capitalize on the Haight's reputation.

When the San Francisco-Oakland Bay Bridge was completed in 1936. The American Society of Engineers named it the seventh wonder of the world. The 8.4-mile span is a combination of a suspension bridge from San Francisco to Yerba Buena Island and a cantilever bridge from the island to Oakland.

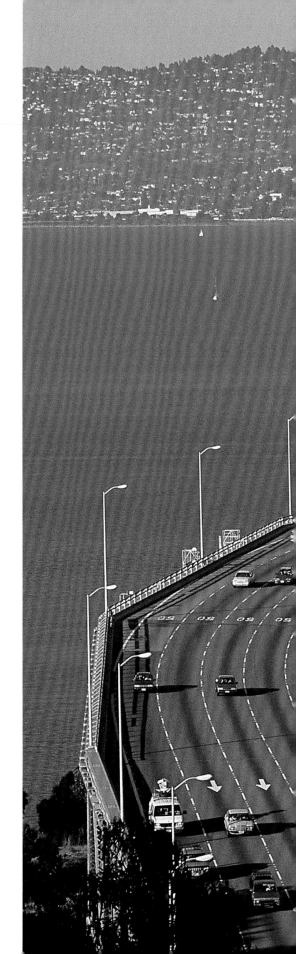

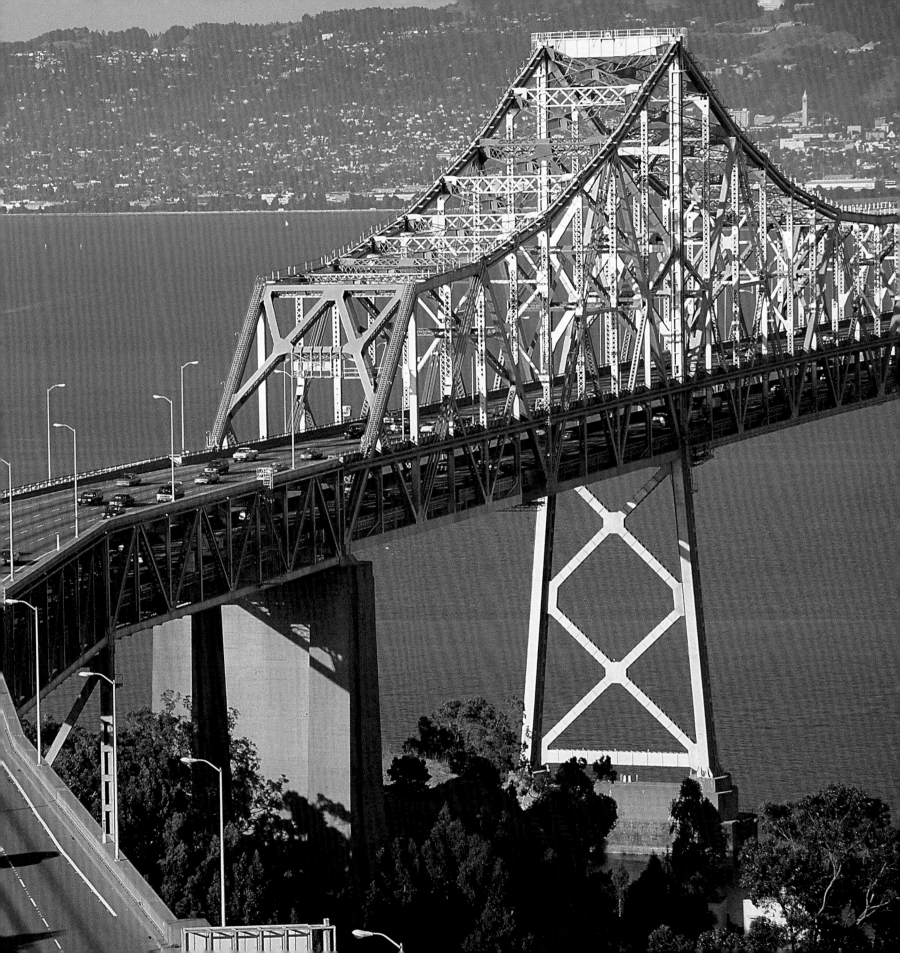

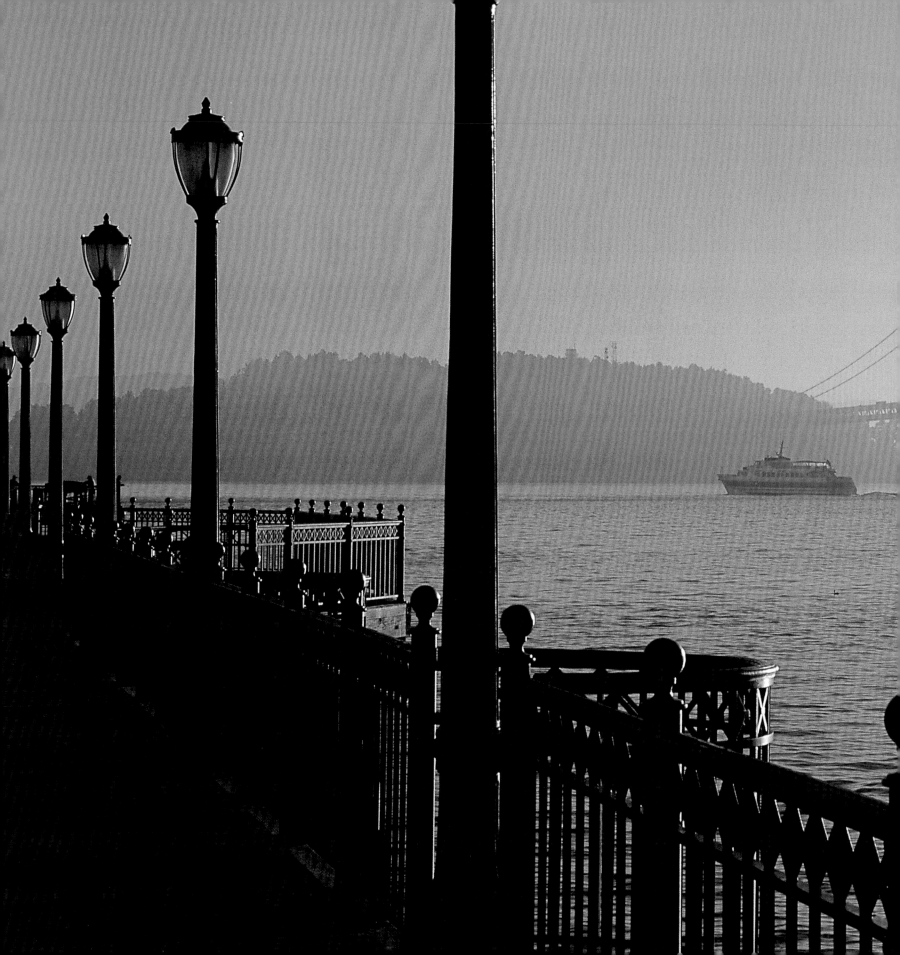

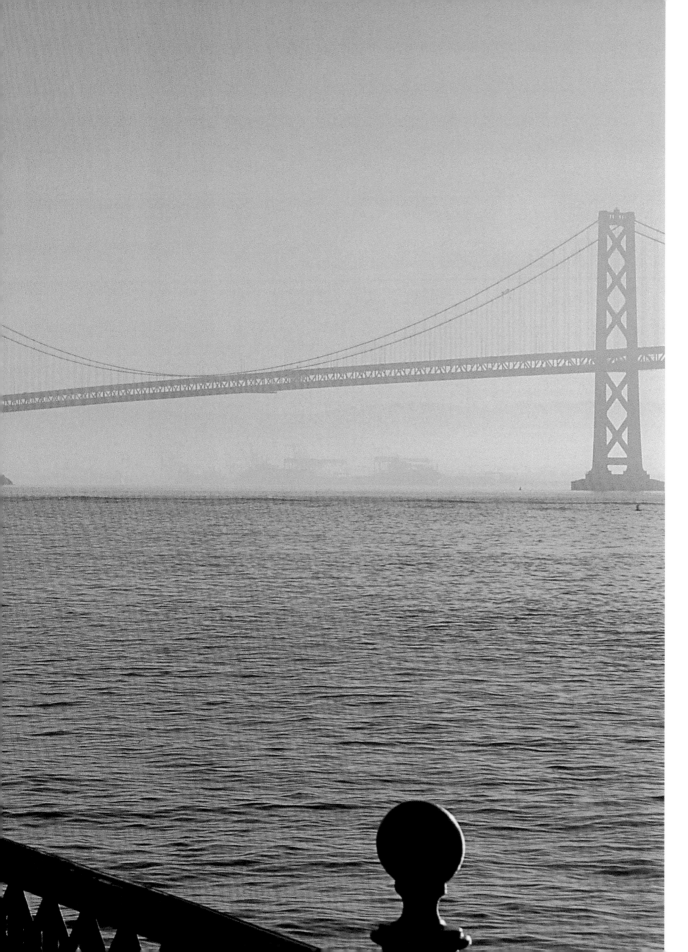

As the fishing and shipping industries declined in the 1960s and 1970s, San Francisco shifted its attention to business and finance. Today, most trading is no longer done at the piers that surround the city, but in the downtown office towers.

Just across the Golden Gate Strait from San Francisco, Sausalito is a quaint collection of houseboats, houses, and shops perched at the water's edge. When this town of 7,500 was founded in the late 1800s, it was named for the *saucelito*, or "little willow trees" that eighteenth-century Spanish explorers had noticed along the shore.

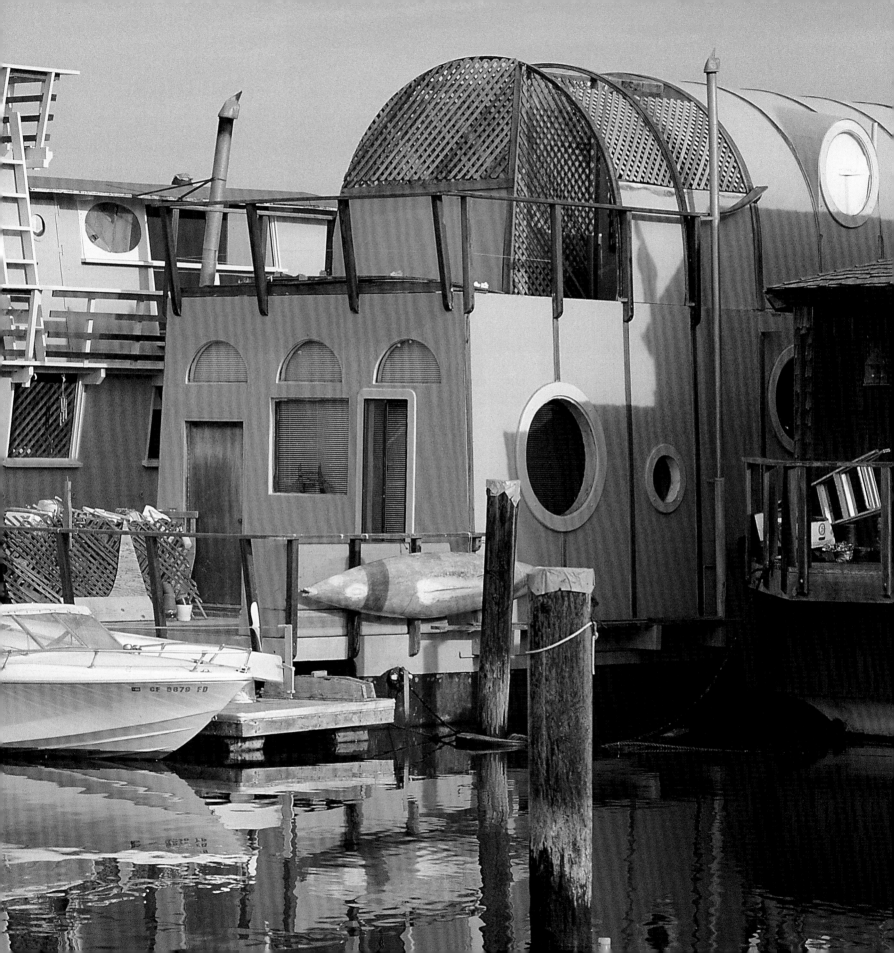

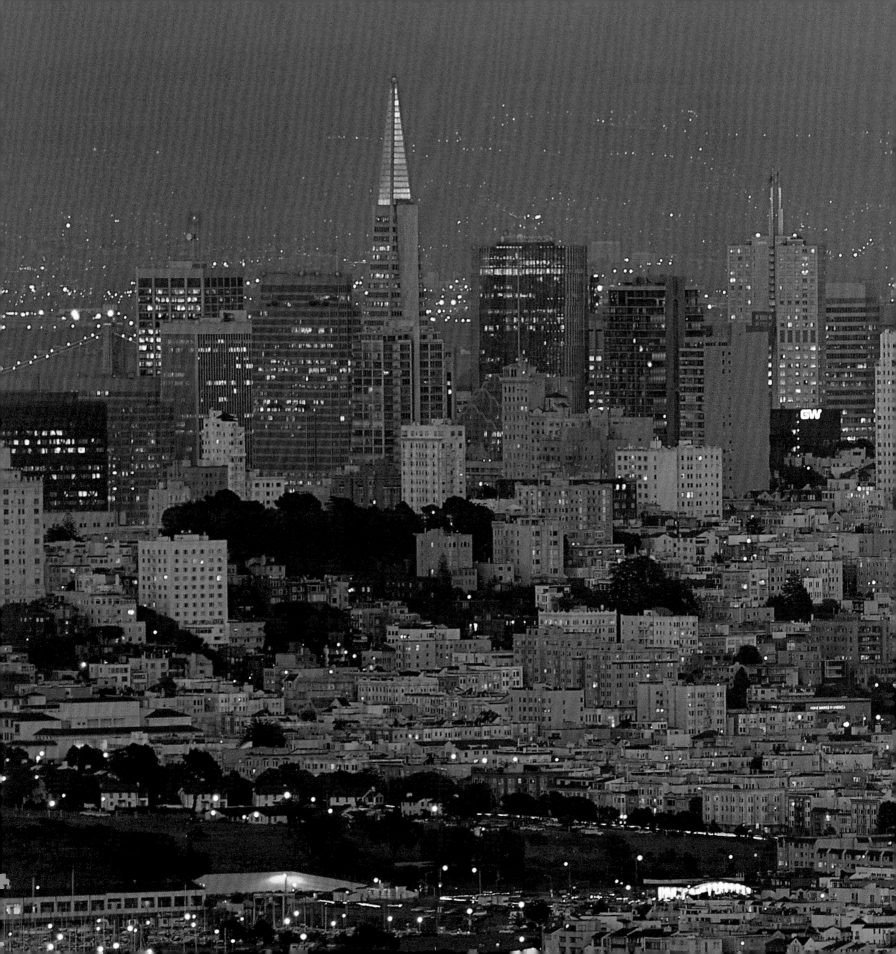

Although only about 776,000 people live in the city, the metropolitan area surrounding San Francisco, Oakland, and San Jose is home to more than 7 million. Another 17 million people visit San Francisco each year.

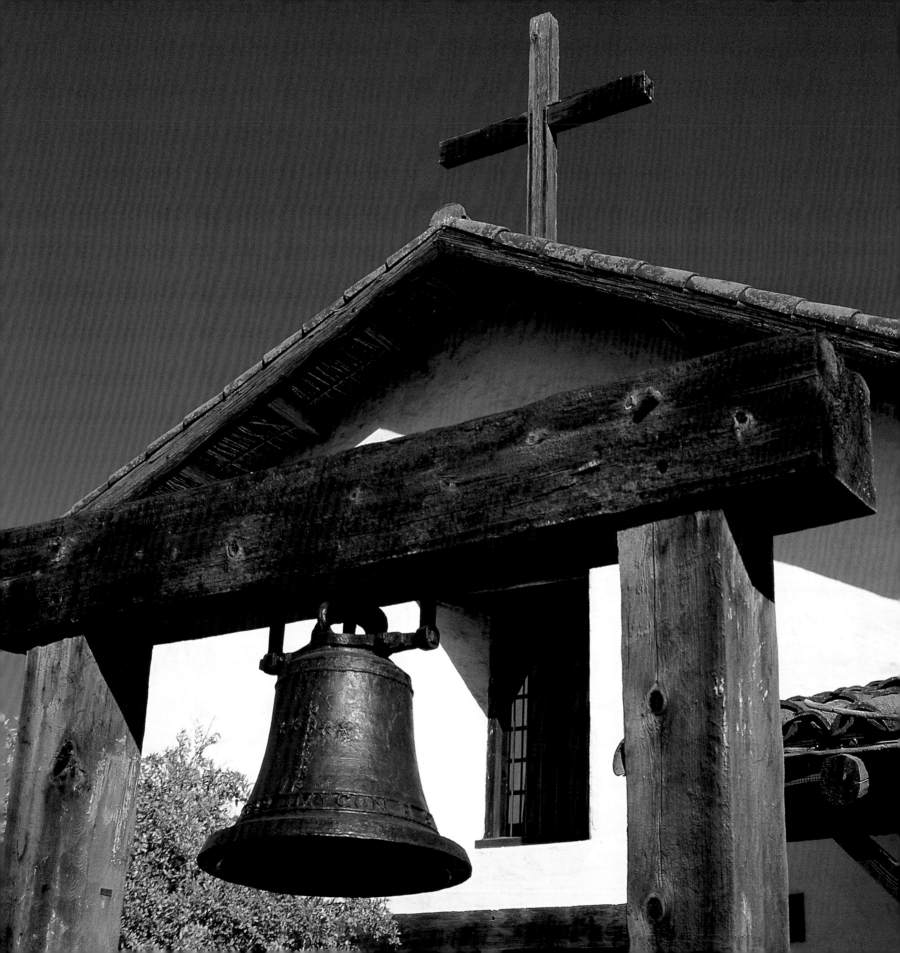

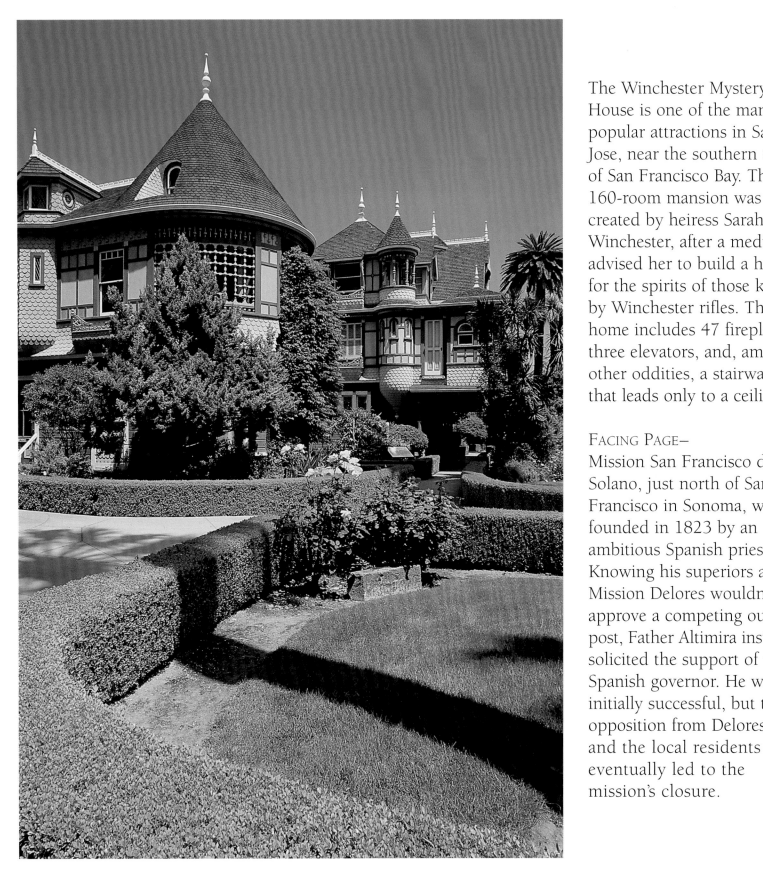

The Winchester Mystery House is one of the many popular attractions in San Jose, near the southern tip of San Francisco Bay. The 160-room mansion was created by heiress Sarah L. Winchester, after a medium advised her to build a home for the spirits of those killed by Winchester rifles. The home includes 47 fireplaces, three elevators, and, among other oddities, a stairway that leads only to a ceiling.

FACING PAGE–
Mission San Francisco de Solano, just north of San Francisco in Sonoma, was founded in 1823 by an ambitious Spanish priest. Knowing his superiors at Mission Delores wouldn't approve a competing out-post, Father Altimira instead solicited the support of the Spanish governor. He was initially successful, but the opposition from Delores and the local residents eventually led to the mission's closure.

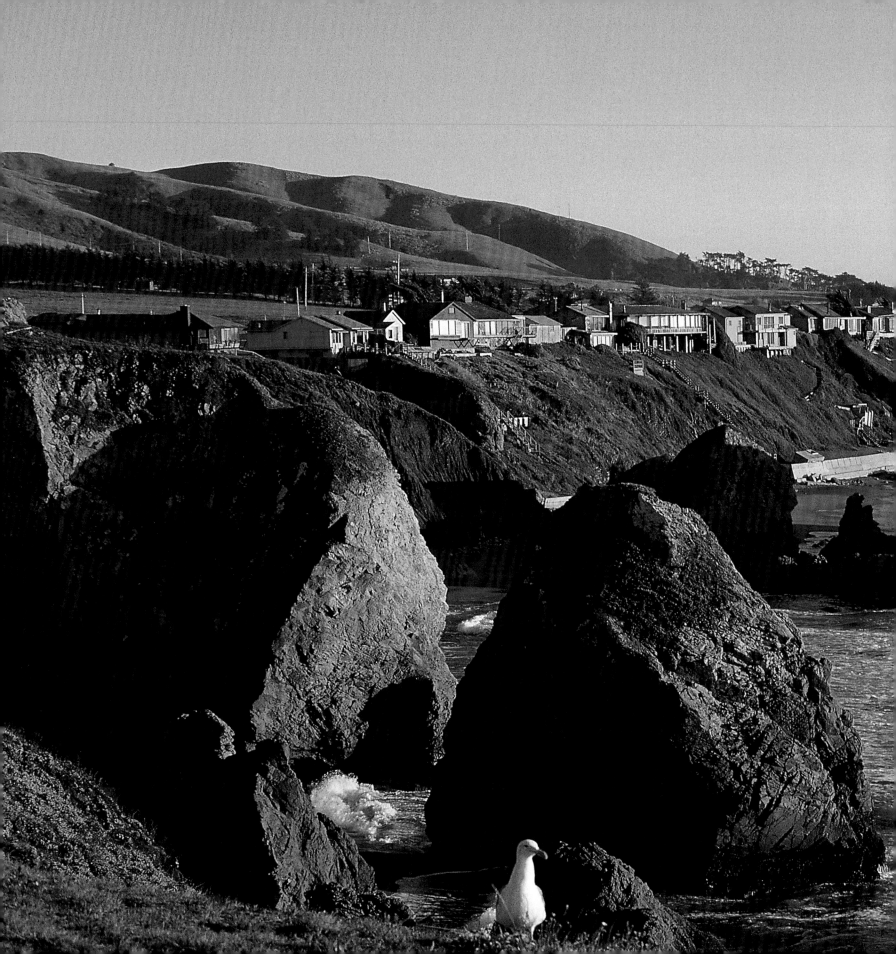

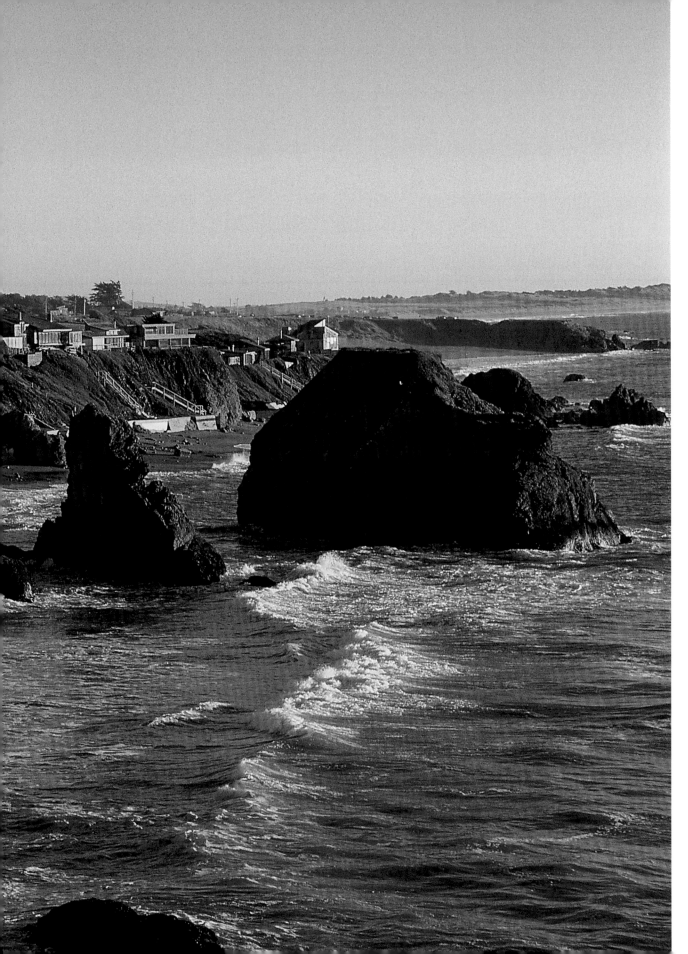

Sonoma County is one of the most popular side trips for San Francisco visitors. Here they discover quiet back-roads, lush vineyards, towering redwoods, and traditional sea-side towns. Local bed and breakfasts, retreats, and spas cater to the growing number of travelers.

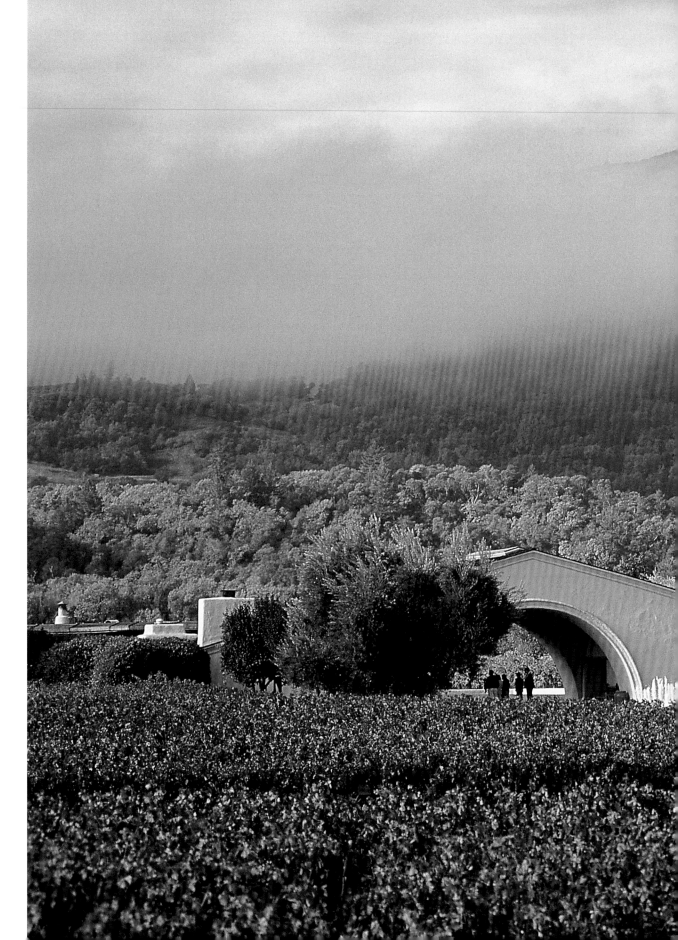

A world-renowned wine region, the Napa Valley north of San Francisco attracts about 5 million visitors each year. The Robert Mondavi Winery was built in the 1960s, the first of more than 200 to take advantage of the region's ideal soil and temperate climate.

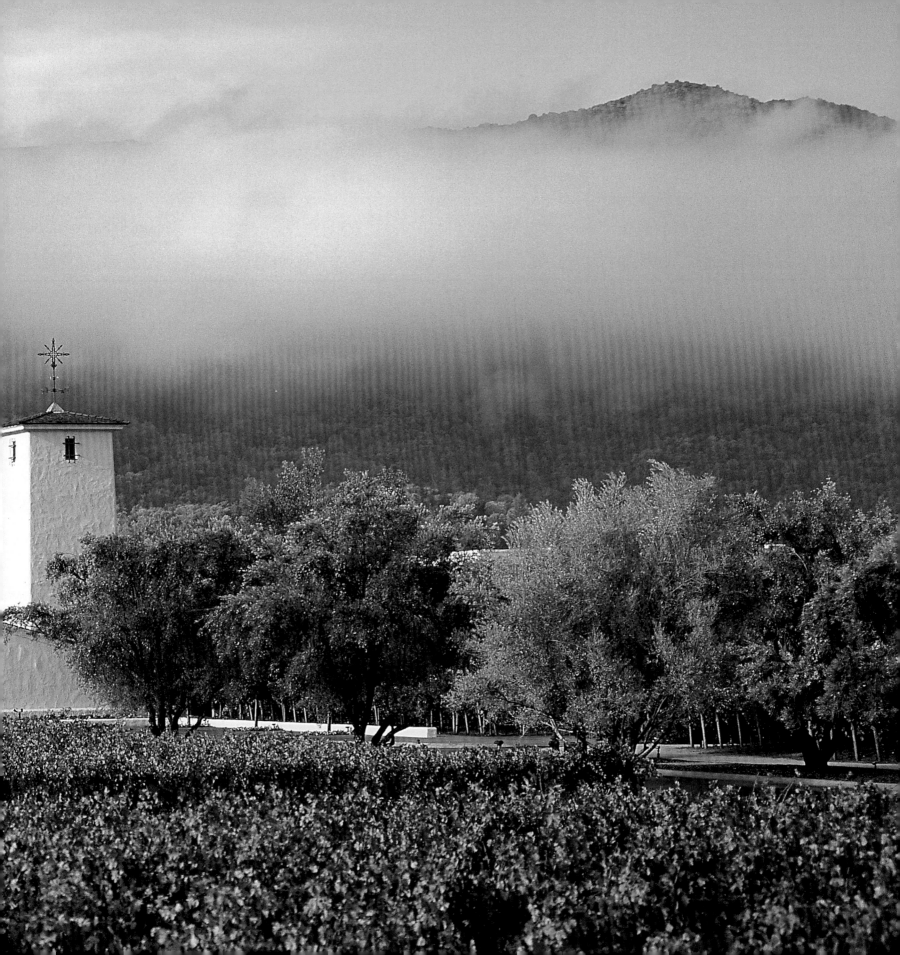

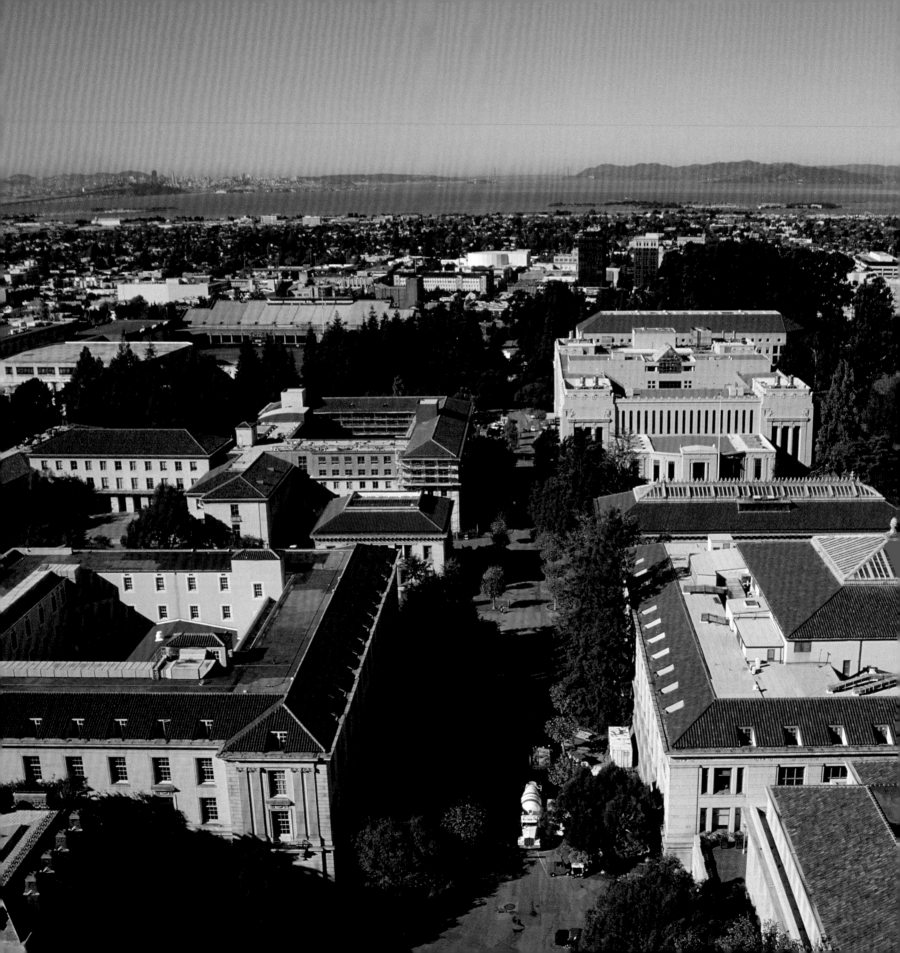

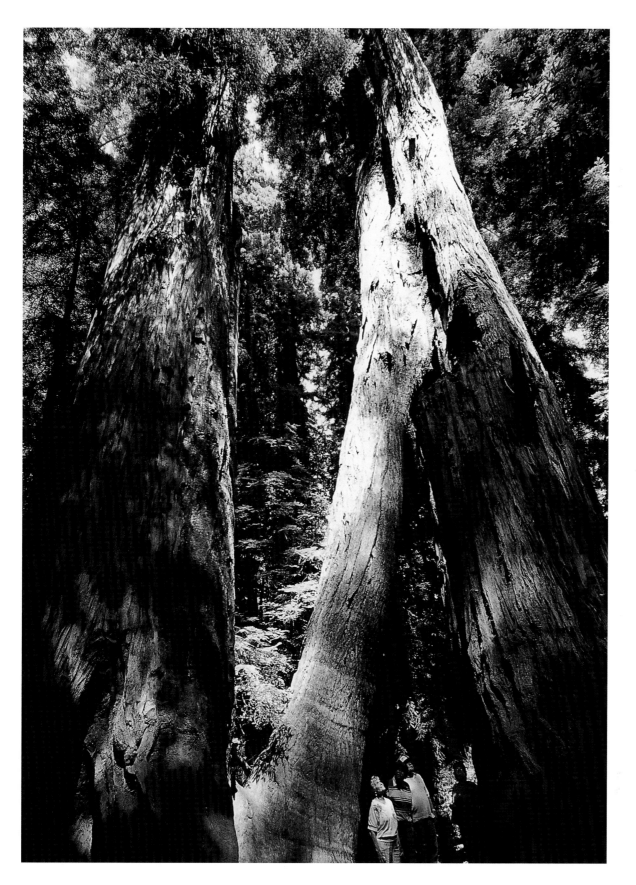

More than 3,000 acres of towering trees shade Big Basin Redwoods State Park, just north of Santa Cruz. Established in 1902, this is the oldest state park in California. It protects trees that were already 1,000 years old when the Spanish explorers arrived on the coast.

FACING PAGE—
The oldest campus of the University of California, Berkeley is perhaps best known as the site of free speech and anti-Vietnam War protests in the 1960s and 1970s. Today, the university's faculty includes eight Nobel laureates and three Pulitzer Prize winners.

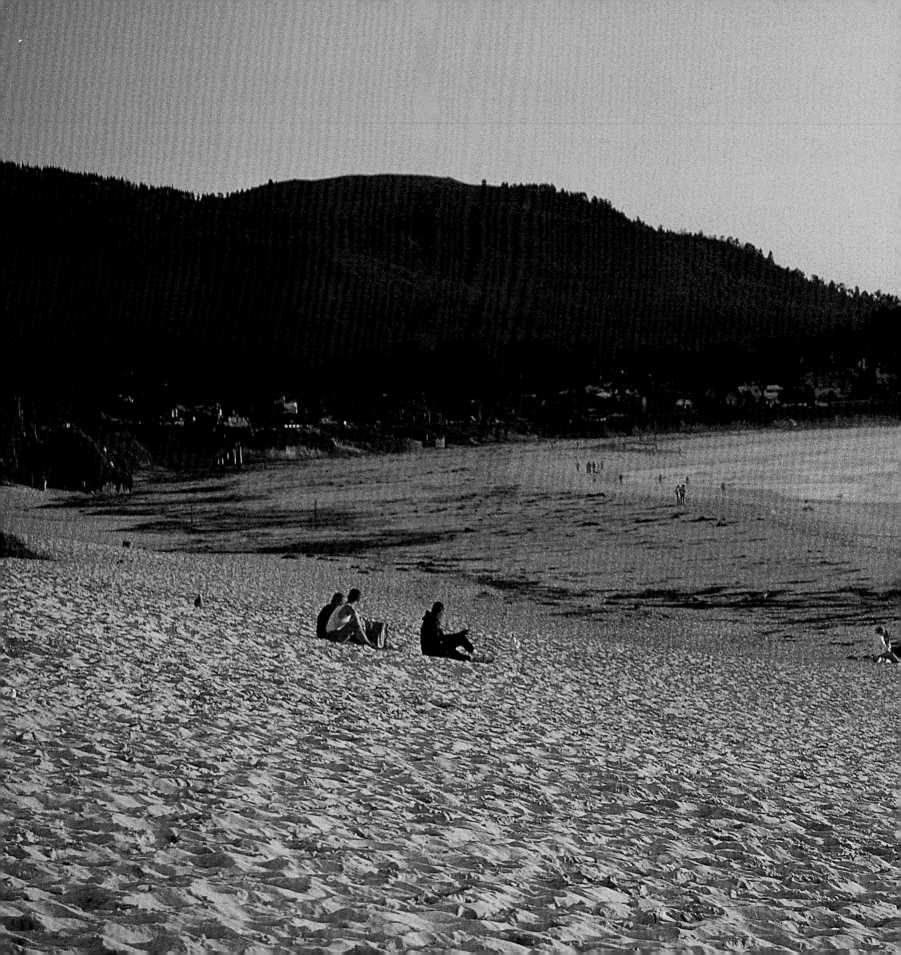

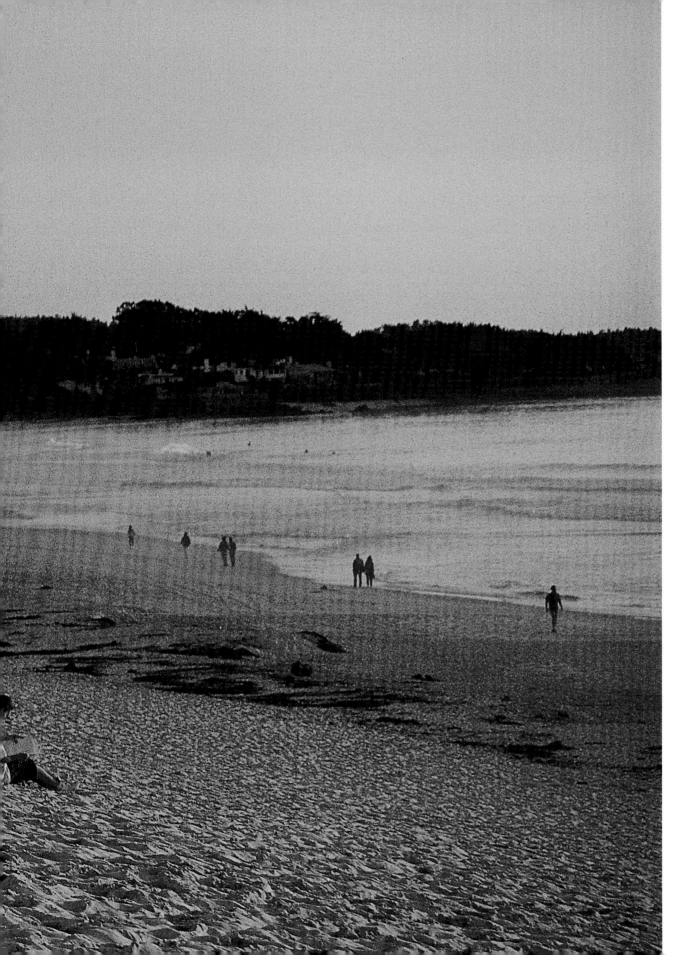

For many travelers, a drive down the coast to Monterey and Carmel is the perfect day-long escape from the city. White sand beaches such as this one await along the highway.

OVERLEAF—
Luxurious Pebble Beach offers travelers their choice of five-star resorts, an exclusive golf course, and plenty of designer boutiques. Many make the day trip from San Francisco simply to enjoy the magnificent ocean views, drive through the cypress groves, and peek up the drives of hillside mansions.

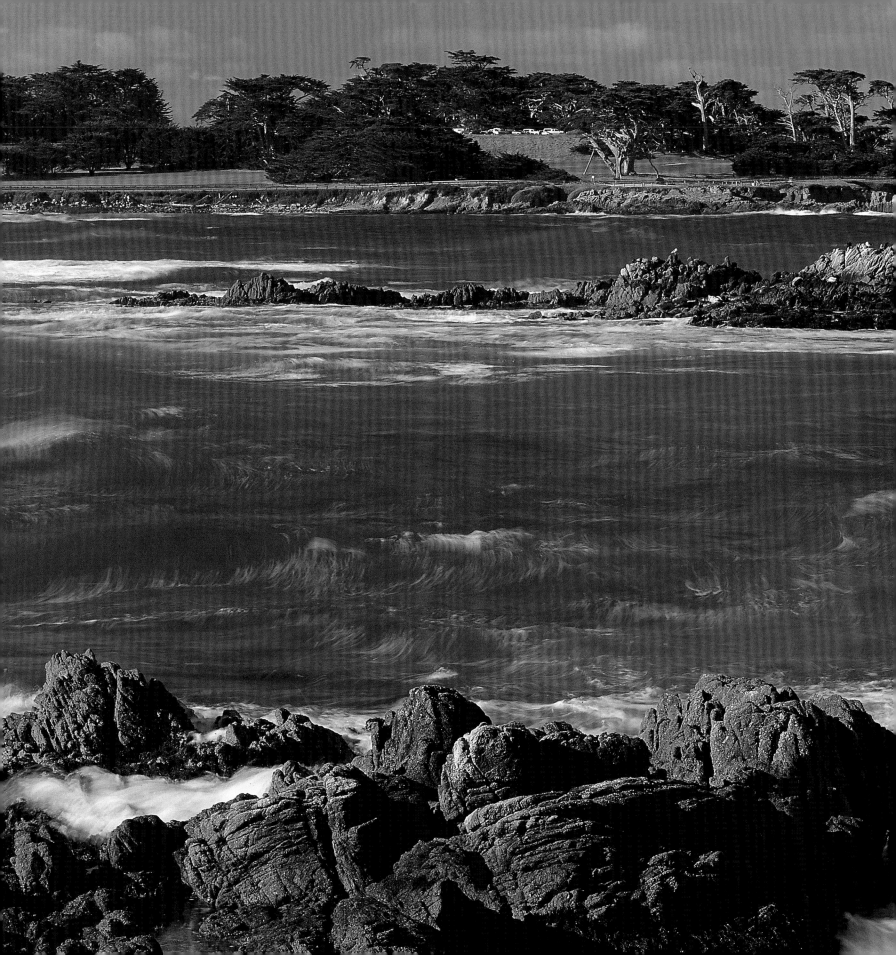

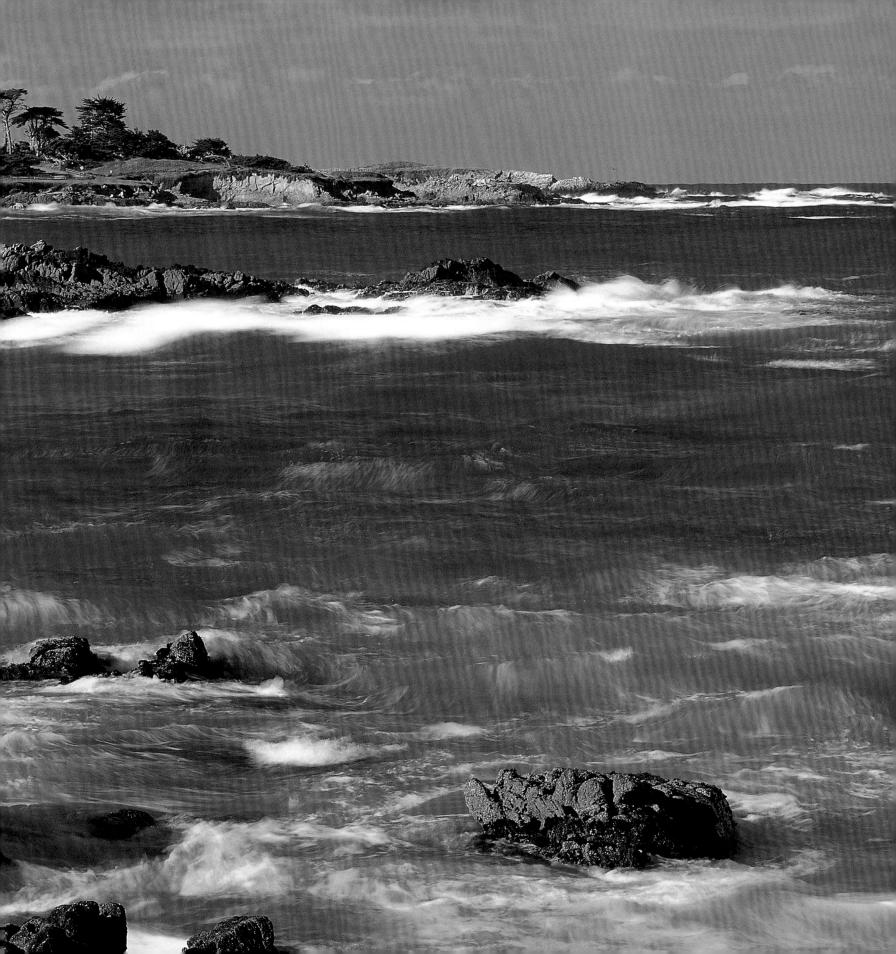

Photo Credits